CONVERSATIONS WITH
Meredith Monk

THE PERFORMANCE IDEAS SERIES

PERFORMANCE IDEAS explores performance that crosses boundaries of all live art forms and media. The series highlights the long-standing commitment of PAJ Publications to bring together the histories of performance in theatre and in visual art for an expansive vision of artistic process.

OTHER BOOKS IN THIS SERIES

The Sun on the Tongue
Etel Adnan

art is (speaking portraits)
George Quasha

newARTtheatre: Evolutions of the Performance Aesthetic
Paul David Young

EXPANDED EDITION

CONVERSATIONS WITH
Meredith Monk

BONNIE MARRANCA

New York, New York

Conversations with Meredith Monk is published by PAJ Publications, P.O. Box 532, Village Station, New York, NY 10014. Distributed to the trade by Consortium Book Sales and Distribution: www.cbsd.com

Publisher of PAJ Publications: Bonnie Marranca

Special thanks to Peter Sciscioli at Meredith Monk/The House Foundation for the Arts, and to Joseph Cermatori, for their help in preparing materials for this volume.

Conversations with Meredith Monk

Expanded edition

ISBN 978-1-55554-166-8

Library of Congress Control Number: 2020943363

CONTENTS

PREFACE to the second edition
Performance as a Life Science vii

PREFACE to the first edition
Setting Questions to Music xi

PART I 3

PART II 39

PART III 71

PART IV 93

PART V 135

LIST OF IMAGES 169

BIOGRAPHICAL NOTES 171

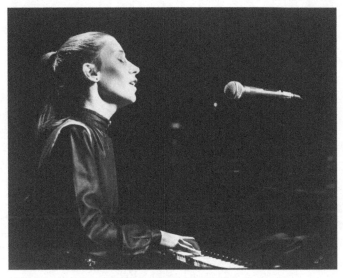

Meredith Monk singing "Gotham Lullaby," 1981. Photo: Johan Elbers.

Performance as a Life Science

The long conversation that brings this expanded edition to a close takes the life and work of Meredith Monk up to the present moment, joining the talks that start with her beginnings in the 1960s as an artist in New York City. Here there is advice for the young artist and the wisdom of the elder, joining the reservoir of childhood memory to the urgencies of adulthood. It is not surprising that a substantial part of this conversation focuses on the question of time. Not only was it undertaken after the first showing of the film restoration of Monk's masterful opera *Quarry* (1976), but also after the revival of her opera *ATLAS* (1991), the first occasion that a work of hers was staged by someone else. The exchange that ensues on the essence of artworks and the way that they engage the idea of the contemporary at shifting cultural moments provides some of the most suggestive explorations in the volume. How do artworks maintain their integrity of form? Where does the identity of an artwork reside? These remain complicated questions for an artist.

Since *Conservations with Meredith Monk* was first published in 2014, there have been premieres of the new music-theatre works *On Behalf of Nature* and *Cellular Songs*, and another one, *Indra's Net*, is in progress. That Monk is refining each piece to its elemental being is exceedingly apparent. For an audience, just looking is not as resonant as experiencing feelings of intimacy and tactility that are at the heart of a performance. The theatrical is less prominent than the musical as the later work

has become more abstract, Monk admits. What comes through in these conversations is the constancy of an artist's yearning: to learn more, to search for new forms, to act in the world. Considered in a more spiritual timbre, I would describe this feeling as a striving for grace.

Influenced by her thinking about human cells and the microcosmic/macrocosmic aspects of the universe, Monk articulates the development of *Cellular Songs* as the desire to create a work that demonstrates care and collective effort as an antidote to the destructive aspects of human activity. If the earlier *On Behalf of Nature* brought to the forefront an ecological theme, *Indra's Net* continues a focus on the interdependence of nature and human beings, which is to say, the body of the world and the human body. In an illuminating detail, Monk observes that her earlier pieces used layering as a structural component, while in the recent *Cellular Songs* the melding voices of five female singers generates the sense of "three-dimensional sound sculptures."

On the audience experience of the work, Monk perceives: "There is something about when you are in the moment, and you know that you are really present, that allows something to go through you, so there is a kind of radiance or luminosity. The other thing that is very beautiful is vulnerability. Vulnerability is one of the most valuable qualities that we have to share with other human beings." In the purity of its regard, a chamber piece like *Cellular* Songs is a splendid example of Monk's value system weaving through multiple vantage points within a performance: structural, social, and ethical. Genuine

performance thinking at this level can only be found in the intense embodiment of ideas that animate a space.

This creative period of Monk's work manifests a distilled, poetic quality that joins the moral and the aesthetic, a relationship in art that has always attracted me. In a significant revelation, she offers that *On Behalf of Nature*, *Cellular Songs*, and the still-developing *Indra's Net* form a trilogy. It is rare for a group of contemporary performances to be envisioned as a unified trilogy on a special theme, but this declaration only serves to highlight the continuity of her vision. Framed in this broad vista, what Monk proposes is essentially a view of performance as a life science.

Even though our latest conversation focuses on more recent events, what comes through in all of the talks is that Monk has followed her own life force as a guiding spirit, with the result that she has built a highly individualized performance vocabulary. She imagines the audience as a congregation and the work as an offering, song as prayer and walking as procession, a cast as a community, and, most profoundly, art practice as spiritual practice. The Buddhist foundation of her body of work—in particular, its contemplative register—has only deepened over the years. In her vision of an ephemeral art form, the ephemerality of life has grown more insistent as a motif.

So much can happen in the world over time to cast a body of work in new social dimensions. When Meredith Monk and I sat down in the winter for our last conversation, we could not have imagined the cloud of unknowing that would descend upon the world in the form of the coronavirus months later.

Now, thinking about her work against the background of life *in extremis*, it is evident that Monk had already acknowledged both the always unknown future and the resilience of human beings. For decades her body of work has been rooting itself in the recurrent themes of spiritual quest (*Songs of Ascension*), healing (*The Politics of Quiet*), compassion (*mercy*), plague (*Book of Days*), fragility of life (*impermanence*), cultural identity (*Ellis Island),* historical trauma (*Quarry*), ecology (*On Behalf of Nature*), and community (*Cellular Songs*).

In *The Human Condition*, Hannah Arendt set forth an ineluctable truth: "Artworks clearly are superior to all other things. They stay longer in the world than anything else, they are the worldliest of all things." Since, as I've always believed, artworks live their own lives in the world, it is only through living with them over time that their capacity for the regeneration of meaningfulness can be experienced. And if we are so fortunate, we can enter into artworks just as we can look inside ourselves, following pathways of understanding previously unknown to us.

<div align="right">

Bonnie Marranca
2020

</div>

Setting Questions to Music

One of my favorite passages in these conversations is Meredith Monk's description of how she works. This is what she says: "I always allowed myself to think of my forms as bottles, but my process as a liquid. If there was something from the bottle before that I hadn't totally realized, I allowed myself to put that into the next bottle. Maybe I would develop it a little bit more." Those words reflect so much about her way of working—the feeling for form, utter clarity, process before product, economy of purpose, trust. At its core a cumulative, step-by-step path to art-making.

What is that quality of endeavor we call "art"? How does an artist describe all the elements of the self and the world that create an artwork? In *Conversations with Meredith Monk* we explore these questions, leading us into unexpected realms. Mostly, we sat down at her kitchen table or my dining room table and began to talk, to see where our thoughts would take us. In embarking on this volume I was fortunate to have such an articulate conversation partner whose body of work in music, theatre, performance art, visual art, movement, video, and film extends five decades, prompting our discussions to consider historical legacies as well as the contemporary, within the expansive contours of a long career. For, what can be understood without bringing the two together? How does an artist start to take a measure of where she is now in relation to where she began many years ago? Wisdom is the other side

of virtuosity, an attribute I welcome in knowing an artist's work over decades. Who is this woman sitting before me, in the twenty-first century, someone I as a young writer first saw perform in the mid-seventies? How does she do what she does?

Monk entered the arts scene in New York, in 1964, upon graduating from Sarah Lawrence College. Part of our conversation recalls the work she saw, what she performed in, what she read, and the early work she made. A multidisciplinary artist from the start, she experimented with live performance and technology, in as many forms as she could develop, questioning the nature of perception. There is also the childhood and college preparation that got her to this point. She was always living in art. Most revealing are the moments when Monk talks about the struggle of a young artist to find her artistic identity and to learn how to work with elements of performance and media. Sometimes the joy of discovery is mixed with the pain of rejection.

What's apparent at the outset of these conversations is that her primary method is to ask questions. I like very much that our exchanges are punctuated by the kinds of queries she makes for different works over the decades. Monk says that once she gets the questions she is asking about a piece, then she's on her way. For the recent *On Behalf of Nature* the question was, "How do you make an ecological artwork, thinking of all the physical materials and not creating waste?" For *Education of the Girlchild* it was, "How do you make a non-verbal portrait of one woman's life?" For *Songs of Ascension*, she considered: "How do you get people out of that audience situation to become a congregation?" Her bottom line question: "Are we

going to have objects?" Objects have a syntax, a language, like every other element in a performance.

Monk trusts her basic process: to find out what the world of the work needs and what its principles are. Then, to understand what is right for that world and to bring it into existence. She speaks of "beginner's mind"—going into a project with an open mind so that something new can come through. That is not to say there isn't any fear or risk. Monk has plenty to offer about confronting the unknown and searching for the path into a work, available liquid notwithstanding.

Yet, the theatrical works are not weighed down by any sense of ponderousness. I've always enjoyed the lightness and humor in them, no matter the theme: quirky turns by the performers, witty songs, instrumentalists who lie on the floor. It must also be a great pleasure for the splendid company members, many of them working with Monk for decades, to sit as they do along the periphery of a performance space, watching each other perform, before getting up for their own turns. They seem more like a community than a cast. "My group is still part of my body," the artist observes.

What one understands from these conversations is just how demanding is the *work* of getting any piece to completion. Monk's precision in describing how she develops the space in a theatrical event or film is quite formidable in its remembered detail, particularly in the comments on earlier works such as *16 Millimeter Earrings, Juice,* and *Quarry.* Time and space structures set their foundation, the staging ideas often worked out beforehand in line drawings, maps, or charts. Struggle is a necessary feature of the process. Nowadays it impacts the musical

in relation to the theatrical, as increasingly music composition comes to the forefront. The music is becoming more and more free-ranging in new dimensions of sound and feeling. Something she admits to still figuring out is the less complex staging that is the result of that development. Like any artist with decades of experience, Monk values the essentials, only what is needed. Work with the givens. Similarly, she talks about a special visual condition she has, known as strabismus, which makes the retinal experience different from seeing objects in a more tactile, three-dimensional sense. This way of seeing is reflected in a certain layering in the pieces.

At their heart is the idea of weaving. Such a metaphor refers not only to the frequent mingling of music, theatre, media, and movement in them but also to the more Buddhist notion of the interpenetration of perception and sentient beings. Monk refers often of the Buddhist principles in her work, especially in linking art practice to spiritual practice. For her, performance space is sacred space, a meditative space. An offering to the audience. Her theatre is a deliberate alternative to the speeded-up, distracted way of contemporary life that, she believes, prevents people from direct experience. Rather, it encourages a certain mindfulness and the beauty of quietude. The music, the human voice, grows more astonishing in the variousness of its presence, bringing forth a new kind of music-theatre that honors the ancient and the contemporary, the liminal and the here and now. What is one's work doing in terms of the world? she wonders. Philosophic worldview metamorphoses into performance ethics, a feeling of grace that encompasses our world and worlds unknown.

A final question. "Part of the strategy of being an artist is, How do you create an experience for people that allows them to see and hear in a new way? It opens up the possibilities of perception, so that when you go back into your life you might be more open to the moments of your life, and see things you haven't been aware of before."

What things? I ask.

Bonnie Marranca
2014

impermanence, 2006. Photo: Stephanie Berger.

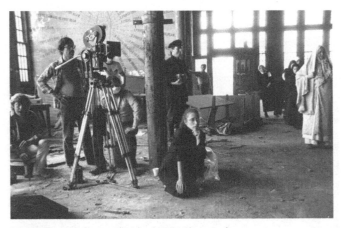

Meredith Monk filming *Ellis Island,* 1981. Photo: unknown.

CONVERSATIONS WITH
Meredith Monk

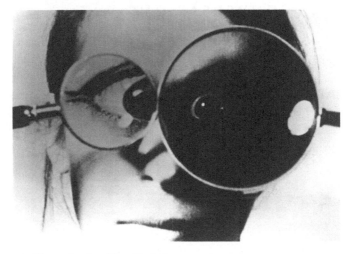

16 Millimeter Earrings, film still, 1966.

I

*Let's begin with the early years, primarily the sixties and the sev-
enties. You graduated from Sarah Lawrence College in 1964,
and came to New York City at a time when, just to mention a
few things, there is Cage and Cunningham's work, and Fluxus,
Pop Art, Process Art, the Judson Dance Theater, experimen-
tal film and theatre, sound art—all of this is occurring in the
decade of the sixties.*

Not all of that by the time I came to New York, though. The two
big painting schools that I was very aware of when I first came to
New York were the Pop artists and hard-edge abstract painting.

*By the end of the decade we are beginning to see all of the art
that I mentioned.*

I think you have to be very clear about what happened when.
There were certain things that happened definitely after 1966
or around then that were not happening earlier. There was a
shift in sensibility around 1966. When I was at Sarah Lawrence
I did a combined performing arts program. I was in the Voice
department and the Dance department and I was doing some
theatre. Because Sarah Lawrence only had three study courses,
each course was almost worth two other courses in a regular
college. You went very deeply into your subject. You couldn't
take a big spread of subjects, so I was very aware that I hadn't

3

had art history. I decided to educate myself. My last year there I went through all these art history books, piles of them. When I first came to New York, I was very interested in going to galleries and in what the visual artists were doing.

What were the issues that occupied you when you were in school and wanting to be an artist? Talk about the kind of arts training you had and the issues that preoccupied someone wanting to be an artist in the early sixties.

I had music my whole childhood, and then I had movement coming from my Dalcroze Eurhythmics background. And I did a lot of acting as a child. I think my concern when I was working at school and already making pieces was how to integrate all these elements into a form. I wasn't totally successful at it at that point but I was really glimpsing the possibility. I was lucky enough that my teacher, Bessie Schoenberg, was a woman of the theatre in the broadest sense of the word. She taught dance and dance composition but her mother had been an opera singer and she really had a sense of theatre as a whole performance idea. When I was there she was the director of both the theatre and the dance departments. Bessie was a visionary person and she tried to see who each person was. She had certain principles of motion, of structure, of form, that could apply to any medium. It could apply to music as well. And theatre. She taught basic principles but, at the same time, she was very open to each person manifesting these principles in their distinctive way, which was very unusual.

Ruth Lloyd, my music teacher, immediately saw my musical capabilities. A funny story I always tell about being at Sarah Lawrence is that they would do the dance concerts and I would be onstage doing movement, performing with somebody, or doing my own movement, and then I would be jumping down into the pit to play four hands with Ruth for somebody else's piece. It was always something that they accepted in such a strong way. At that time, if you saw people's work from other schools, all the work looked exactly alike, whereas at Sarah Lawrence everybody was so unique. That was something that gave me a lot of courage to find my own way.

It seems like growing up as a child with an interest in so many art forms was already preparing you to be a multi-disciplinary artist.

I think so. It was necessary for my identity as an artist and as a person. Weaving these elements was not something that was an aesthetic choice. It was almost a psychic choice to be a whole human being. Later on, when I got to New York and I was trying to work in this way, I also realized at a very early stage that it had social ramifications. The idea of pulling together perceptual modes and trying to put them into a form was, number one, affirming the richness of us as human beings, both as audience members and as performers. As performers we could fluidly go from one mode to another. I realized that Western art was quite unique in the fact that it usually separated these elements. There was a specialization in the Western European approach whereas, if you thought of African culture or all of the Asian theatre, they combined many different forms.

I read a book on Asian theatre by Faubion Bowers, maybe my second or third year in New York. I had never seen these forms, but just reading about them was so inspiring. I felt that he was saying, in the description of these forms, a lot of what I was trying for—the fluidity of moving as an actor into movement, into singing, with objects as another element.

Were you already thinking of these things as a student? Did any of your training open up those areas?

I remember Bessie giving one assignment of singing and doing movement. Since I was also a singer, I think that my result was very successful. I wove them together in a rhythmic counterpoint. She wanted us to sing a song and then work with movement at the same time. That was really important. Because I was also a singer and a musician I was able to do a counterpoint relationship. That was one of the first times Bessie saw that I had something really unique to share. One more thing about weaving these elements. I realized the social ramifications were that, if you could make a—I hate to say this New Age word— "holistic" form, it was going back to some of the origins of performance. In all the accounts we have of ancient performance, those things were woven together: music, movement, storytelling, and ritual. That was an antidote to the fragmentation and specialization of our world. I was already, as a very young person in my twenties, aware of those possibilities.

I think it is important to know that, because the sense of ecology is a very long-lasting theme for you. It started, apparently, just before the counterculture push.

Just before, exactly. Around 1966, when I made *16 Millimeter Earrings*, that is when I felt the huge cultural change. That is when we also heard of the Be-Ins in San Francisco. There was a big shift in 1966. Also, I was trying to contend, in some way, with technology. The piece is very much about the relationship of live performance to technology. In this accumulative structure that I made, which was not a linear structure but more spiralic, each section is introduced live. If I am singing the note "ah," then my voice comes on tape and takes over and becomes a loop in the sound landscape. I was trying to work with how technology could also be poetic and could have the liveliness that a live performance has.

> *Now, five decades later, you are saying that, in 1966 when you were working on it, you were already thinking about some of the issues that have only come to prominence in much later times, like the idea of "liveness" and mediated performance. Is it live on tape? Is it feedback? Does it have to be a live performer? Also, the McLuhanesque ideas were coming into the culture at that time.*

Marshall McLuhan was very important to me as a reader. I was also reading a lot of Ouspensky and Gurdjieff at that time. In that way of thinking, they are talking about different centers— spiritual center, intellectual center, physical center. I was thinking, How do I make a theatre that manifests those centers that are also an affirmation of the audience's abilities?

> *What people were interested in then was performance, consciousness, energy, perception. Weren't they all issues that concerned artists?*

With *16 Millimeter Earrings*, you could say the subject of the piece was perception, perceptual modes. Also, I was thinking a lot about displacing principles from other forms and, if you shift to another form, you find out new ways of dealing with that form. When I first came to New York, I did a piece called *Break*. That was about how you would make a solo, live performance piece that had a cinematic syntax or cinematic continuity. How do you make a piece that has cuts, dissolves, and the vocabulary of cinema? How would you do that as a live person with the continuity of only one person? Very quick changes of intensity, of emotion, of persona, of focus. A very disconnected kind of piece, but with a continuity of a live, solo person. I was very excited by cinema at that time. How would you learn from that syntax? How would you take that syntax into live performance?

I use film as a real basis of concept later on in 1970 in a piece called *Needle-Brain Lloyd and the Systems Kid: a live movie*. That was a piece that had about 150 people in it. It was a huge site-specific piece that took place over four hours. The audience moved from space to space and, in that, I was consciously making a piece that was like a film. Except it wasn't a film. I was using close-ups, long shots, dissolves, all that kind of film vocabulary. But I think the other thing that was really interesting to me at that time when I was making *Break*, in 1964, was the idea of a discontinuity in time and space, which was hard to achieve because I was a live performer in the same room. How can you make a live performance that has the feeling of discontinuity of time and space? It was done in a very pure way. It is only a seven-minute piece.

To go back to something you said before, you were trying to do the same action or gesture but in different media, so that you started something live and then it went on to tape.

That was *16 Millimeter Earrings*. That was later. *Break* is much simpler, but it was inspired by cinema as a language.

What is interesting about so many things you started early on in the sixties, now that we're talking about the concept of presence and what is live, is the sense of a live movie. That is also a concept that you now see artists working with for perhaps the last ten years or so. It takes the form of performers singing during a movie, usually a showing of a classic film, and it includes a score.

That's a little different idea. My idea was, literally, how do I make an epic film? But there was no film in the piece. It was live.

But you called it a "live movie." Many of the concepts or ideas, if not the exact ways of working…

Yeah, not the manifestations.

…have been elaborated over the decades to where we are now. Early on, when you started with media, you were asking these questions. Some of them seem to come out of the ideas of Intermedia, when Dick Higgins wrote his manifesto in the mid-sixties.16 Millimeter Earrings was an Intermedia piece. You were already creating a dialogue between media. It wasn't just using media as illustrative.

Exactly. I was thinking about it more as poetry. More like taking a motif and then manifesting it in objects and film and performance. I called it "visual rhymes." For example, with the motif of fire in *16 Millimeter Earrings* you see these little paper flames coming out of a table. You see my hair and I have this red wig like I am on fire. You see a little doll dressed like me in a miniature room burning on a huge, twelve-foot high screen. Then the film cuts to flames. It is taking the idea of fire and manifesting it through these different media. Then you get a different sense of tactility, texture.

And you have text, too. Text is another texture.

Each section is dealing with a different world. There is the world of objects, the world of words, the world of singing, the world of gesture. I isolated them and then wove them together.

You were also very interested in experimental film at this time.

I was going up to the Thalia, the Bleecker Street Cinema, the basement at Carnegie Hall, and my friend Phoebe Neville was dragging me to the Toho Cinema to see Japanese films. I was seeing a lot of the New Wave films, I was seeing classic films. *Last Year at Marienbad*, I remember very well. I saw it in college. Bessie Schoenberg and I used to talk about it. I was reading Husserl in my philosophy class at Sarah Lawrence. In French class I read Robbe-Grillet's *La Jalousie*, which is very connected to phenomenology. I think it was about the power of objects and the objective world in itself. That was also a

strong sensibility, for example, in the Judson Dance Theater. It was like, "no to emotion." It had to do more with making the emotion implied rather than expressed. That was really interesting, but I think I was always more emotional and had a more emotional intensity as a performer.

To make the distinction a bit more, it is an emotion that is felt but not shown.

That is very well said. Or implied by the objective world, like *La Jalousie*, which has the Venetian blinds and the patterns of light created from them, and you are seeing the centipede on the wall. You are just looking at images. Underlying that you feel the emotional world, but it is not expressed.

You spoke earlier about coming to New York and feeling that your work was expressing, by its form and structure, a certain sense of the social.

I don't think I was there yet, but I felt like the social resonance occurred to me as I was already starting to work perceptually, formally, and structurally. That became something I realized was not only about art but it also had a resonance in social forms.

You evolved in that direction. But now you are saying there was a philosophical underpinning. That is a good subject to explore in terms of your use of objects and perception and seeing.

And also what you would call my deadpan performing style of that period. That philosophical base had to do with the fact that the human being was one element in the performance environment.

It was a flattening.

It was a flattening, but with the belief that the flattening would still be more expressive. Or evocative. It wasn't flattened just to be flat, like some people's work, to do "zero" work. I never did that with the thought that it would end up as flat. The flattening had to do with knowing that the underpinnings would come through more. At least that was my personal belief system at the time.

By the late sixties Roland Barthes's Writing Degree Zero *had been published. This sense of flattening to the zero degree in perception was very much in the air in movies and in literature.*

I think so. We had come from abstract expressionism and Martha Graham. Everybody expressing. I think this was a dialectical position.

The beat poets, too. There was a lot of hot work.

And the other was quite cool. And yet, as I have always said, I am not really a cool temperament. That was something I had to navigate. *Break* was very, very intense, but there was also a sense of irony and humor to it. It was poignant and humorous

simultaneously. I made my own soundtrack. In those days I only had a two-track tape recorder and I figured out how to layer by recording on another tape recorder and recording back and forth. I made a very complicated track of car crashes. You could say that was quite violent against the deadpan, Buster Keaton-style.

It was a layering style. What was it like, dealing with a certain theatricality and expressiveness when you think of the Judson Dance Theater then? I'm thinking of Yvonne Rainer's "No to Spectacle."

Don't forget that her "No To Spectacle" comes in the mid-sixties. She was able to integrate her thinking into that manifesto. But I think the sensibility I am describing was very much there. In that way, my generation was very different. My colleagues were Kenneth King and Phoebe Neville. We came on to the New York scene at around the same time. Kenneth, when he first came to New York, was doing very theatrical pieces. Then he ended up, strangely enough, going more into movement and then text. His early work was very theatrical and media-centered. Phoebe was a dancer but she was also a wonderful actress. We had that in common. We were going for a much more theatrical way of doing things. Ultimately, it was a kind of dialectic to the Judson Dance Theater.

At the same time Fluxus as well was non-representational and conceptual and objective. But the artists also did wild, expressive things like smashing violins and pianos.

I have so much gratitude to the Fluxus people. They were very welcoming to me when I first came to New York. I think they saw what I had with all the different possibilities of form. I could sing, I could move, I was an actor. And so they asked me to perform in their pieces. I think the fact of these different modes was not a big deal to someone like Dick Higgins. He was also a wonderful musician himself and a wonderful actor, and then when he ended up performing with me he was a great mover with his body, in his own way.

Which pieces were you working on with him?

I was in the pieces that he did in 1965 at the Sunnyside Gardens Arena, a boxing ring. One of them was *The Tart*. *The Tart* was a great piece, but the piece I really loved was called *Celestials*. That was beautiful. I performed in other Happenings with Dick and Alison Knowles. We used to do Happenings at the Café au Go Go on Bleecker Street.

With Al Hansen, too.

Dick and Alison and I were in Al Hansen's work. And also in the work was the sculptor William Meyer.

That's when I met Dick and Alison. I felt that they understood my need to utilize these different modes of performing. It wasn't just movement. I was singing. I was acting.

What years were these?

That was only 1964, 1965. By the end of 1965 most of that activity was over. The last piece I performed in by someone else was the fall of 1965, and that was a Carolee Schneemann piece called *Water Light/Water Needle*. That was pretty much it for performing with other people. I was doing my own work, too, and I got overwhelmed. I was taking a taxi from one place to another, performing. That is how crazy it got.

This was before Yoko Ono's Chamber Street series?

No, it was after. By the time I got to New York, it was over. That was in the early 1960s. I met Yoko when we were doing Jackson Mac Low's *Poems for Dancers* in the Avant Garde Festival in 1965.

Run by Charlotte Moorman.

Right. I was working with Jackson, Phoebe, Kenneth, Iris Mac Low, I don't think Dick and Alison were in that, but it was *Poems for Dancers*. The 1965 Avant Garde Festival was when Alison, Dick, and I, and Philip Corner and James Tenney, did a realization of Satie's *Relâche* from the instructions. We showed the film *Entr'acte* as part of it with Philip and James Tenney playing four-hand piano Satie. I wish there was a videotape of that. We started it as a very period piece and, little by little, it started deconstructing. We all worked on it together.

Dick and Alison were very important to me. All of those people were really like my elders. They were not my mentors in style, because I already knew that my style was different.

So I would never say I was influenced by their style, except by their purity of intention and task-oriented way of perform-ing, which I always loved. Over the years, when I taught work-shops, Dick came to some of them, and so did Jackson and Geoff Hendricks. I loved having those Fluxus people in my workshops because of the way they would fulfill a problem I would give. It was so utterly refreshing and direct. They were so important to me in spirit.

Coming into this milieu and finding some types of art more to your spirit, and certain clusters of artists more welcoming, what kinds of things do you recall grappling with? Were there technical problems? Were there philosophical issues? What were you trying to solve for yourself around this time, looking at these different landscapes and aesthetics?

As any young driven artist—and I *was* utterly driven—I think that my twenties were literally my life-or-death exploration of finding my artistic identity. It had a lot to do with identity. This happens with every young artist. I had to keep my inner courage because my work was put down a lot by critics. I had reviews that would make your hair stand on end. I always say that I wonder with some generations if that is a way of building your inner strength and integrity. In a way, I was very lucky.

Let me just tell you, I am now reading the second volume of Susan Sontag's journals, from this same period, and there she is writing about the devastation she felt when people criticized her novels and films.

It is so painful. The difference between being a younger person and an older person is that the pain takes you a year to get over when you are twenty-three. But when you are my age, it takes one minute. You're really hurt, and then goodbye, it's over.

What were the critics troubled by?

Part of it had to do with the fact that my work was, even at that time, between the cracks. If you had dance critics, it was definitely not in line with what "dance" was then. For example, I got what you would call at the time "uptown dance critics." First of all, they shouldn't have even been dance critics, and, secondly, they had no idea whatsoever of the questions and problems that I had given myself. They didn't have a clue about the vocabulary of what the work was addressing. They slammed it out of ignorance.

Also my body type was not a dance kind of body. So there were a lot of vicious, very personal things. At a certain point, I just let it go. I was not even interested in dance. I am not putting down my background in dance. I always am grateful to the dance world. I always want to make this clear. In a way, the dance world was more advanced than any other world at that time. People could see what I was doing. But really, I did not identify myself as a dancer and choreographer from *16 Millimeter Earrings* on. From then on I knew that I was a theatre artist, theatre in the largest sense of the word. I knew that I was wanting to make a visual theatre form. I wanted to make a theatre of images. That is really what I was doing. It was much wider than dance.

I had a real crisis in early 1966 when I realized that I was wound up in the vocabulary of movement but that it was not the right vocabulary for me. The ins and outs of movement were almost too introverted. I felt that it didn't express. It didn't read. That was when I slashed that away and developed a larger concept of images. Movement could be a part of that, but it had to have some conceptual base so the movement could make sense. That is what happened with *16 Millimeter Earrings*. I really started working with materials more like a visual artist. It was a non-verbal form and I did move from one structure to the next, but I was very much thinking of images. There was film as well. Within that the world of gesture and movement were one world. That was the section where I do these little movement things to a description of making large movement and then also intercut that with Wilhelm Reich's *The Function of The Orgasm*. That was a big breakthrough. My identity was no longer that of a dancer and a choreographer.

That, I suppose, is what you consider your first important work.

That was my breakthrough work. *Break* was important, but it was a small work.

When I think of the theatre at the time, the Living Theatre existed, as did the Open Theatre, La MaMa, Judson Poets' Theater, Caffe Cino…

The only thing I saw at La MaMa was *America Hurrah*. It was at at Cafe La MaMa on Second Avenue. I did go to the Caffe

Cino and saw *Dames at Sea* with Bernadette Peters tapping on a tiny stage. I didn't see the Living Theatre until 1968, when they performed at Brooklyn Academy of Music. But Phoebe was close to them and told me a lot about *The Brig* and some of the productions. And at the Judson Poets' Theater, Al Carmines, Remy Charlip, June Eckman, Gretchen MacLane, and Florence Tarlow did those wonderful pieces.

They did charming art-world type pieces like What Happened *and* In Circles.

In Circles was later. I hadn't seen much of the Judson Poets' Theater although I had performed in one of their pieces as a singer in *Pomegranate* by Harry Koutoukas. That was in the spring of 1966. Right before *16 Millimeter Earrings*. I was one of three flowers and sang a high soprano part. Remy Charlip did the costumes and Aileen Passloff did the choreography. That was wonderful. I could go into my more theatrical kind of approach. I was really singing in that piece.

At Sarah Lawrence I was in a lot of pieces by John Braswell and Wilford Leach. They weren't at La MaMa yet, not until the late sixties. In John Braswell's work I was a musician, I did percussion. That work was very inspiring to me about integrating music and theatre. John Braswell's work was excellent. Bill Finley was in some of those pieces. I'll never forget their *Threepenny Opera* as long as I live. I wasn't in it, but I think it was one of the best *Threepenny*'s I have ever seen. Thinking back, that was very important to me.

In 1965, I did some choreography for Jerry Bloedow, who was a poet, and one of the founders of the Hardware Poets Playhouse. I also did my own piece there called *The Beach*. That was a piece based on a poem by Jerry. It turned out to be a very disjunctive solo—extremely theatrical. I was painted white from head to toe. I had created a character called The Beach Woman.

In a way, what was beautiful about being in New York at that time was that all these glimpses that I had and all the intuitions that I had as a student were affirmed. I used to go and see everything. Seeing all of that made me feel that I can do this. It made me realize that I had begun to find my own way, and that this was possible. Another thing about the Fluxus group was that there was a spirit at the time that *anything* is possible.

We haven't talked about the Happenings. Many of them were still being performed in the sixties. Robert Whitman considered his own Happenings as theatre. They were also very image-oriented.

Definitely Whitman was a big influence. I thought his work was so beautiful. I always have. He got metaphysics into his work.

And science—for example, in American Moon.

But also the relationship between film and live performance was inspiring. *Prune Flat* was very beautiful. I also loved what Robert Morris did in some of his dance pieces. He reduced

movement to images. He was also very witty in his use of objects. Another person who meant a lot to me at that time, I'd only seen one piece but it really knocked my socks off, was Peter Schumann. I saw the piece that was called *Fire*. There was something about this metaphysical and spiritual kind of complexity in the guise of simplicity. I always felt that Peter's work was very complex on the inside but simple on the outside. The intensity and the purity of it, I'll never forget.

What else were some of your touchstones?

Though Carolee Schneemann's style was coming very much from abstract expressionism, what was interesting to me was the fact that she used physical materials in such a fluid way. That was inspiring for *16 Millimeter Earrings*. Maya Deren was influential in that disjunctive way with time and space. She is a real predecessor for me in my use of film.

Were you interested in Jack Smith's work? Or any of the artists of the Ridiculous?

I never saw Jack's work at that time. I didn't see it until many years later. And I was not aware of Charles Ludlam and John Vaccaro until later in the sixties. In 1967, I moved to 9 Great Jones Street. I always tell this story: I was a young girl, I was twenty-four, and I was in this loft on the top floor all by myself. In those days Great Jones Street was kind of a scary, rough area. The first night I was in the loft, I heard these blood curdling screams. It turned out that John Vaccaro had his theatre on the

second floor and through the elevator shaft I was hearing one of their rehearsals. I became more aware of Charles in the early seventies. Every year in the sixties was so specific. You can't imagine. There was a shift of culture. By the fall of 1966, for all intents and purposes, that was the end of Happenings. That year was also *9 Evenings*.

Did you see any of those now historic performances?

I was working on *16 Millimeter Earrings* then and I was very nose to the grindstone. I pretty much had blinders on, working on my piece. I only saw Lucinda's performance, and John Cage's evenings. John Cage's *Variations VII* and Lucinda's *Vehicle* were very haunting in their own way. But the Cage one was really interesting because everyone ended up sitting on the bleachers until they realized they could just walk around. It became a big party. You were seeing all your friends and going close to each of the sound stations. It became a big field of activity.

The critical reception of 9 Evenings: Theatre and Engineering *has always been so controversial, with some critics calling it a failure because so much of the equipment didn't work, and others valuing it for the experiments in art and technology. It is really interesting, as you were saying before, that so many of the critics have had such a hard time understanding new work. But there were the more receptive downtown critics, particularly at the* Village Voice, *like Jill Johnston in dance, Michael Smith in theatre.*

I would say that with *Education of the Girlchild*, I have never read a person who wrote more eloquently about that work than Michael. He wrote a short article but what he said about the work got the essence of everything in my sensibility. And Jill, of course—we were scared to death of Jill. She was a laser beam, an X-ray machine. She understood what the questions and concerns were. She really influenced the field of art criticism. Her way of thinking about things had something to do with phenomenology. That also came from Robert Dunn's Composition class. What are you seeing? Her writing was more what she observed. Through that you could also tell what she thought about it. Her observation was a way of conveying the phenomenology of an event. All that the critics had done up to that point, mostly, was express their value judgments.

By the time you made 16 Millimeter Earrings, *Susan Sontag's influential essay "Against Interpretation" had been written. Do you recall any discussion about it?*

I remember talking with Kenneth. He had a lot of interest in Susan Sontag. I remember "Against Interpretation," and also her amazing essay about science-fiction movies from the fifties.

It was "The Imagination of Disaster."

That was brilliant. It really influenced my thinking. It was very much about when you see a whole genre, what are the underlying themes that are unsaid but are manifest in that genre? All the Cold War concerns and 1950s' fear and anxiety put into

forms. This was an affirmation of my idea of layering. Or many people's idea of layering.

What other authors were people reading in those years? What about Cage's writing?

I didn't read *Silence* until the early seventies, until 1971 or 1972. I loved the writing. He was so affirming about the artist's role in society, and the purity of making work.

Were you reading Allan Kaprow, or other artist-critics?

I never saw Kaprow's pieces. Of course I read *Artforum*. By *16 Millimeter Earrings* and another piece that came before it called *Duet With Cat's Scream and Locomotive*, I was already beginning to work with objects and thinking about strange combinations of elements. There was an entire issue in fall of 1966 in *Artforum* about Surrealism that was very evocative.

I was going to ask you about that in regard to 16 Millimeter Earrings. *Were you influenced by surrealist film?*

Definitely. More from the ideas rather than having seen many of the films.

The use of objects is interesting, too. It is still the case that many artists working in performance come out of sculpture. Perhaps not enough is written about or thought about in terms of the objects in performance.

I remember when the term "performance art" came into play—that would have been in 1977. I thought that was strange. We had been doing this work at that point for almost twenty years. That label came out of the art school mentality. It really was visual artists coming into the performative mode. This is not a value judgment on any level. But I think that with those of us coming from performing and using visual elements and image and object and light, the one thing we had that was different from the visual artists was the fact that we used time as an element. Time and timing. Whereas, in a lot of the early pieces of the Happenings, the time element was not worked with. It was really more the idea of image. Wait for a long time. Then the next image. Wait a long time. That was the thing that was not so satisfying in terms of a performative form.

I was surprised at the recent Chelsea exhibit on Happenings— itself a rarity in that most of the art world attention has gone to Fluxus—how theatrical and narrative the films and photographs of Claes Oldenburg's work looked. It would be interesting to compare the set designs of the Judson Poets' Theater and other Off-Off Broadway productions with Happenings.

The base of the Judson Poets' Theatre was musical, because of Al Carmines.

There were also the plays of Maria Irene Fornes and Rosalyn Drexler, who was both a playwright and a painter. In fact, Rosalyn's paintings were in the same Happenings exhibit I referred to.

Irene and Rosalyn came from a theatre background. Time is
used as a structural element. It is very different—the continu-
ity. Someone like Ken Jacobs, for example, I didn't know his
work until the mid-seventies, but I thought his work was so
haunting.

 *I remember his Apparition Theatre in the late seventies, where
 he would just project images.*

I saw a piece called the *Boxer Rebellion* that he did in 1975. It
was a series of images like photographs projected onto grave-
stones. You had to wait a long time from one image to the next
but in his case it was well worth it. The time element was not
necessarily thought of as a sculptural element. I think I could
say that pretty much across the board.

 *I was rethinking Happenings in terms of how some of the work
 seemed closer to theatre at the time, even the look and the design
 of it. For example,* Nekropolis, *Oldenburg's piece. We started
 talking about theatre and performance art—Irene Fornes was
 in some of the Oldenburg Happenings, and Rosalyn Drexler
 was painting and performing. The Living Theatre hosted art
 events. There were crossovers between visual artists and theatre
 people as well as dancers. Robert Whitman even did an opera
 at that time. His work was always more scenario-oriented and
 poetic.*

I think that is why I liked his work. It was very metaphysi-
cal. Magical. His work was very much about phenomena and

magic. I was deeply inspired by that and felt very close to it. Invocation—in a way you could say his work had that. A kind of mesmerizing, metaphysical feeling.

He was the only Happenings artist who had that. He didn't like the term Happenings, he used the term "theatre." What I am saying is that there is so much more that we have to think about and learn, especially in light of the current theatricalization of performance. We have been limited by the lack of substantial history books about performance and by the photographs and videotapes not always being available, though video does exist for Whitman and Oldenberg and some of Schneemann.

I agree. The history of that period is very sketchy. But even with photographs and video, you can never really see what was going on. That ephemerality for me is the sadness and the beauty of live performance.

What also struck me about the Happenings, and you would probably be interested in this with your use of so many different performance styles…

Not styles, but means. Modes.

Okay, modes. Looking at Jim Dine's work, and Red Grooms, you can see what they took from vaudeville and burlesque. That is what I mean by saying there is so much more to the history of performance. Looking at the Robert McElroy photographs of Happenings presented new images I hadn't previously seen.

Much of the early documentation available is by Peter Moore,
and I was already familiar with those photos. With the new
Pace Gallery exhibit I can see there is more of the circus, more of
vaudeville, and older forms of comedy in Happenings than his-
torians have actually explored. Most of the histories have been
written about by art history scholars who don't know the history
of performance or theatre history.

Exactly. There were such a variety of performance modes that
are not known or acknowledged in the limited histories we
have of that era.

Turning back to your own history, how did you evolve from the
smaller pieces to such large casts of sixty-five or one hundred
fifty people, with more complicated structures? I am thinking of
Juice *and the* Tour *pieces.*

I did one other piece called *Children* after *16 Millimeter Ear-*
rings, but really the next major piece was *Blueprint*, and that
was 1967. It was my first site-specific work and, secondly, my
first duration piece. It had more than one part and you went
and had a ticket to both parts. They were linked up, and so
when you went to the second part some of the memory or the
resonance of the first part became part of your present-tense
experience. That opened up quite a bit there, because the idea
was that you could have a piece that takes place over a month,
with the two parts having something do with each other.

The first part of *Blueprint*, which I did in the Judson Gallery,
was more an installation. People did come in, but there were

just two of us sitting there. It was a very visual theatre event. We were just sitting there like objects. The audience sat there and simple events happened, and finally at the end the audience went to the window and it looked like we had disappeared out the door to the garden. You saw the backs of our heads but it was life-sized dummies I had made. We were in the closet, actually. They were very simple, austere, and pure images. Then, the audience came back a month later and some of those images either repeated or were variations of them. I used the upstairs sanctuary and also downstairs in the basement at Judson. I took the whole space apart and kind of excavated it.

What led to that work?

I got tired of the stage and was very interested in reality. Again, thinking of it as a filmmaker, I wanted to use the space as it exists out here in the world, and has so much magic in it. How do you make it so you see it in different ways? The first manifestation of *Blueprint* was done at an artist colony called Group 212 in Woodstock in the summer of 1967. One part of it was in a barn and outside of it there were benches against the wall. You were looking at a building where we had a dormitory. It had six windows and a door. I had events going on in all the windows, such as a film projected on the window from behind. Someone was playing piano in one window. I was singing. There were different events that went in the windows. Finally, the performers in the windows disappeared and you saw a man on top of the building throwing down ten pounds of flour, which made a waterfall. Then there was a procession that went

from the barn past the audience and into the building. As I wrote in notes at the time, the structure of the performance was completely dependent on the structure of the building. That was architecture as structure.

It seems like you moved from a real interest in time then to a study of space.

Both. I think *Blueprint* uses both time and space. *16 Millimeter Earrings*, already in the way that I used the space in Judson or wherever else I performed it, was looking at the space in an overhead point of view. Already I was moving towards the idea of space as a sort of canvas of activity. Spatially, it was very composed visually, as if it were painting. *Blueprint* took that one step further. Then in 1969 I did a disastrous two concerts at the Billy Rose Theatre where I was called a "disgrace."

What kind of pieces did you do there?

One evening was old pieces like *16 Millimeter Earrings* and *The Beach*, and also a new piece called *Title Title*. It was hard. I wasn't ready to be back on a proscenium stage. I'd done *Blueprint* at Judson and then that following spring of 1968 I did something called the *Blueprint Series* in my loft. Bob Wilson performed with me in that piece. It was a piece that was an hour long and there were events that repeated like cycles, which we did up in my loft. I had another set of cycles of activities in the loft below me of the sculptor Julius Tobias, who was my neighbor. I placed different people in a series of still configurations

in large box sculpture that he had made. During that hour, the audience could go back and forth between upstairs and downstairs. This was the first time that I consciously started working with different relationships of audience and performers.

I enlarged these ideas in a piece that I called *Co-Op*, at NYU. So, I was already off the proscenium stage. To go to the Billy Rose was really hard for me. One thing that I did to subvert the situation was that I put large boxes in the lobby, in which people were doing simple activities during the intermission, and the audience could look through little holes in the boxes. In a way, I created a kind of installation piece. I tried to pull out the performing space as much as I could. But it was too pressured for me as a young artist. I wasn't ready to take my ideas and put them onto a stage. After that disaster, where I thought I was going die, the next thing I was asked to do was a piece at the Smithsonian. I could choose any building that I wanted and I chose the Natural History Museum. That was called *Tour: Dedicated to Dinosaurs*.

I am fascinated by the Tour *pieces. Why don't you talk more about them?*

I used about seventy local people in Washington. I made very simple architectural choral work. They had to sing a little bit, they had to do very simple gestural kinds of material. The audience started out in the big dome of the museum and then they moved to another space, the whale room, and then they moved to a tunnel where there were live exhibits, like tableaux. Then they finally ended up in the auditorium. It was a journey—a

tour. I did a dance where I answered the audience's questions while I was dancing. A month later, I made a second *Tour* piece in the auditorium of the Contemporary Museum in Chicago called *Tour: Barbershop*. It was based on the structure of the building. Dick Higgins was in it. I had a big group of fifty people, upstairs in the main gallery, and there was a second room where there were five of us and you could come and look at us very, very close up. Then there was a third space in the basement where you could come even closer and watch and participate in a little game. In the main room upstairs, the performances started far back in the space and got closer and closer.

It was a way of thinking about distance between the performers and audience. I did several more *Tour* pieces in New York State before completing *Juice: A Theatre Cantata in Three Installments*, which took place over a two-month period. The Guggenheim Museum was the first part of it. The second part was at the Minor Latham Playhouse at Barnard.

We started out talking about a piece that was very important to you, 16 Millimeter Earrings. *The lens and the eye are featured very prominently in it. I'd like to talk about the role of vision in your work because you have a very personal relation to sight. How did you regard sight, vision, and seeing in the artistic process of your work in this period?*

If I am speaking about *Juice*, I feel like it has three different ways of perceiving visual information. Even within the Guggenheim there are three different ways of perceiving. The Guggenheim, you could say, is a more sculptural three-dimensional

idea of space. At the beginning, the audience is at the bottom looking up at the vast spiral winding around, and performers would appear in different places on the ramps. That was an overall sculptural, sound immersive experience. In the second section the audience walked up and down the ramps, watching about twenty or twenty-five different events that were going on in the little alcoves. The audience could look very closely at each event and then move to the next one up or down the ramp. Then the audience was up on the ramps and the entire cast came down the ramps to the ground floor and performed a song and dance with one hundred and fifty Jew's harps. The audience was looking from above.

In a way, the whole building was turned inside out. You were looking from these different angles of aspects of the architecture of the building. That was one whole visual situation. In the Minor Latham Theatre, it was in a sense quite flat. Purposefully flat. It worked within a frame to show what the proscenium arch—that existential situation that we take for granted—is.

That relates much more to the vision challenge that I have. I don't see true three dimensions. The condition that I was born with is called strabismus. How it works is that your eyes work independently. If I try to look out of two eyes at a time I see double. Your brain compensates for that by flipping back and forth between your two eyes. Your brain cancels out the other eye so you don't get dizzy. I am not even aware of it anymore. I am not seeing exactly flat, but if you are aware of the way your two eyes come together you are seeing these dimensions on the side. I see distance. If I am looking at this candle as we are sitting at the table, I am not seeing all the elements of the

roundness of that in space. It is more flattened. Close one eye and see what you see. That is what I see all the time. You see distance, you see that the candle is back there, but it is a little flat.

The peripheral vision is so expanded. The dimension is expanded.

Right. Thinking about it now, for the second part of *Juice* I was thinking in layers. It's almost like medieval painting.

It would make sense to be thinking in layers instead of working with depth.

I work a lot in depth, though.

The layers create depth.

Exactly. I was working very much with that. For example, I had in the back of the stage some logs that my father had for me because he was a lumberman. I had them piled up. They started out looking like a log cabin and little by little as one of the logs was taken away you saw behind it a little room. You saw it in strips. It was lit from inside the room. Don Preston, a musician who had been playing violin at the Guggenheim, was in this little room, which was revealed little by little. Again, that was a horizontal type of layers. The third part was a gallery show in a loft. The whole piece was like a giant zoom lens. In the Guggenheim you were moving through three different performer/ audience relationships even within that piece, but there were a hundred people in the piece.

At the Minor Latham, there were nine main characters that had been at the Guggenheim. The audience was able to look at them closer up, and then finally in the loft there were no performers. There were just video tapes of the four main characters who had been painted red, as if the monitor of the video was their head. And you could go and touch the objects and smell them. It became more and more tactile. It was like a zoom lens, something like Michael Snow's *Wavelength*, which I hadn't seen yet. Then in Part Three… I have never talked about this before. I feel very touched to talk about it. I have never analyzed it in these terms. *Juice* is a good example to talk about. In the third part, because it was just in a loft, in one corner of the space I made a facsimile of the room Don was in for part two. One of the things in *Juice* was that it was very much about taking the same elements, and then scale or proximity changes them.

I will give you one example in *Juice* of the transformation of objects. Outside on Fifth Avenue I had someone riding a horse back and forth on the sidewalk. At the Minor Latham I had a little child riding a rocking horse. Then, at the loft there was a facsimile of Don Preston's little room. On the table there was a miniature horse. In the rest of the loft I had arranged all the objects from the other two parts, including one hundred Jew's harps and one hundred combat boots. It was like a garden of all the objects. You could touch them and smell the sweat and everything. Something about that tactility also has very much to do with my eyes.

That is one of the reasons I don't always love the stage. I still fight it like crazy. My way of thinking about things is much more sculptural and tactile because that is the way I see, rather than in depth.

When you think about it, the history of art is the history of how artists perceive the world. Merleau-Ponty wrote an essay called "Cezanne's Doubt," in which he describes how Cezanne was disturbed that the way he saw things was so different from everyone else's. He began to doubt his own vision. Your struggle from childhood to find a way to see, and then making that a subject of the work, is really a key to the work.

I feel that, as my work has gone on over the years, at a certain point the music started to take over. In a way, my visual imagination has gone into the music. I realize that, because of my visual challenge, I probably perceived the world more through my ears. But in a way my brain needed to compensate. I am glad I worked in film and that I did this visual theatre, because it was a way of keeping my mind and my brain healthy. If I have the space I can get the overall structure. It has a lot to do with how a biological organism finds ways to make itself whole. Also, I was not that coordinated as a mover as a little child, and being involved in dance saved me. What would I have done if I did not have movement in my life? I had to find my own way with movement. Having that in my life was my way of gaining health as an organism. It was intuitive. The same thing with my use of space. It is so important to me.

How do the issues around your special way of seeing influence the cinematic language in the feature films you've made?

What I love about making films is the fluidity of space and time and the way that I can juxtapose evocative images with a

concrete space. Both of these aspects are much more difficult to achieve in theatre or live performance, except perhaps in a site-specific situation. Right from the beginning I was interested in cinematic syntax and structure. At first, I used film as one element in my live performances. It was a way that I could introduce another reality that resonated with the live action. Scale was an important aspect allowing the audience to see the whole from a fresh perspective. I made many short silent films over the years. Then in 1979, I made a seven-minute film that I shot at Ellis Island and used as part of *Recent Ruins*. After the performances, I realized that I wanted to try to expand it into a longer film that would stand alone. Making *Ellis Island* was a revelatory and ultimately inspiring experience that led me to make my feature length film, *Book of Days*, in 1987.

Film is a natural medium for me since, as Eisenstein said: "all the art forms meet within the film frame." I have always thought of film as music for the eyes. To me, editing is very much like composing music. Rhythm is a primary element in all my work, and in film attention to rhythm and how the images and sound create counterpoint is essential.

Your work is very integrative and organic. As you move through the decades, do you discard certain things? Does one faculty take over?

Right now, I just wish that I had more visual ideas. I miss some of that. I feel that maybe my visual sense is more in my music and my music is more like a landscape. I don't know why it has happened like that. I have a longing. I keep on trying. But I

also trust the visual simplicity. I trust that it can be simple and more essential. Because I still think visually it is beautiful to look at. It really has a lot going on. It is just less complex.

> *Of course, Gertrude Stein wondered about theatre: Do we get more knowledge from seeing or hearing? How do they work together? She always felt out of sync in her experience of listening to the actors and watching them at the same time.*

That's so interesting.

> *This question of articulation between seeing and hearing is a very strong value for you in the work.*

Yes. A very strong impulse and a strong question and driving force.

(AUGUST 22, 2012)

II

Greetings for the New Year. This was a big year for you, since you turned seventy.

I just turned seventy. It hasn't been a big year, yet. I've just had one month of the year. Girl!

It's a very special marked time. I would like to start from where you are now. In terms of creativity, have you thought about it in different ways over the years?

I have always said that every piece is its own world. I think my job is to, first of all, find out what that world is, what it needs, what its laws or principles are. Once you realize that it is an entity, you listen to what it is saying and sometimes you might have to eliminate your favorite material, but there is something that you sense that is right for this world. Or for the principles of this world. I think that's pretty much the same. The other thing that has remained the same is that once I get the question I am asking about a piece, then I realize that I'm on my path, one way or another. It takes a while to figure out what is actually the question. I don't think the piece answers the question, but you are articulating a question.

Does that mean each piece is a new theme or new problem that you set for yourself?

That is what I have tried to do, and that makes my process difficult. Every piece is very challenging to bring forth. In a sense, it is starting anew each time. I am thinking of a piece, *mercy*, that I did with Ann Hamilton. One of the early questions we had about that piece was, How do you make a piece that is opulent but with very simple means? I think that was our question for that one. For *On Behalf of Nature,* which I am working on now, my question was, How do you make an ecological artwork, thinking of all the physical materials and not creating waste? You are very aware of what you are using and trying to make a piece that doesn't give into consumption. Instead, you are using things that exist, repurposing materials, and creating something new.

> *That is a really interesting concept. Your work has been so centered around an ecological perspective, in the sense that there are many climates in the pieces and nature has been a strong theme. I am thinking of* ATLAS, *which takes place in so many different climates. Or* Facing North, *in a Nordic climate. I am intrigued by what you said about how you use materials and things from the past that you haven't used before. In a sense, what I get from you is that there is a lot of material you accumulate over a period of decades that you can't use in every piece. Is that also a kind of ecological concept—the notion of the ongoing archive?*

In a certain way, it's a spiral kind of idea. Ninety-nine percent of the music is brand new music. But sometimes I look through my old music notebooks and I'll have a phrase or even

eight bars or a fragment of material that I will sit at the piano and play through. And now, since I am older, it seems like I have the capacity to develop some of these forms in a way that I didn't have at that time. It might also have to do with gaining distance from the material, looking at it again. But I have developed whole new forms from material that I didn't know how to use in the 1990s or early 2000s. It is really fun for me. It's spiraling back, but it is definitely making a completely different form.

Writers do that all the time.

Exactly, it is like a music journal.

Going back to something you didn't have the technique or the mental process to include earlier, what things were hard for you decades ago that you can do now?

Thinking about how I have worked with these shards in *On Behalf of Nature,* in the last ten years because I have been working with new instruments or doing pieces for orchestra—it's not just a single keyboard or all voices—the instrumental work has changed my way of thinking about layering, colors, complexity. It wasn't that it was hard for me at that time, it just was a different way of working. But now looking at the same material, I know how to develop it into a richer form than I would have then. I don't know if I would have been afraid. I just didn't have that experience.

In a way, the demands of the increased development of the music moved in so many different styles and ranges.

I wouldn't say styles. It is usually all my style. Forms, or aspects, I would say.

I was thinking of it in the sense of moving from the solo voice to more symphonic works.

Different genres. I see what you mean.

What I think you are saying is that the increasing demands of the music, and where your composition has taken you, have impacted your methods of staging. It would be interesting to know how your development musically coincides or works in opposition to your theatrical ideas. How has one changed in relation to the other?

I am struggling with that now because I think the music is so rich I feel that my staging ideas have to become simpler. Sometimes I miss that image-richness that I don't seem to be getting now. I seem to be understanding more that the images are within the music. It throws me into a quandary as to how I am staging.

Songs of Ascension was a piece where the music was very rich. When I work in a site-specific way, because I love working that way, then the architecture of a building or a situation—working with that spatially—also gives me a richness to draw from in the way that I am staging it, even how music is in

a space. But the stage is difficult. It's a rectangle. It is a particular situation. After I made the piece in Ann Hamilton's tower [*tower · Oliver Ranch*/2007], for me that was working architecturally, sound-wise and visually, in such a wonderful process. It even influenced the way I was thinking about the music structurally. When we got onto the stage, there was a certain point when I remember sitting at this very kitchen table with Ann, saying, "Maybe what we should do is think about it as a music concert with film and simple images."

In a way, that is what *On Behalf of Nature* is, although there are more theatrical elements. I am trying to balance it. What I have always felt in my work over the years is that I don't really know what my form is until I finish making the form. Part of the exploration is between the cracks in these art forms. That's the way I find my richest discoveries. What I have to give is exploring the cracks between the art forms. In the nineties I made a piece called *The Politics of Quiet*. I came into rehearsal with all the music, or a lot of it, composed. The music was really the essential element. I kept on trying theatre elements and images and characters, and this and that, and it didn't want it. What it ended up being was a very geometric staging, and the group was just who they were. They were very developed actor/singers. I had used them in *ATLAS*. In that opera they had characters, like a father and a mother, and this time they were just Tom Bogdan and Katie Geissinger.

When I finished the piece I realized it was a kind of non-verbal oratorio form. It wasn't a theatre piece at all. So then, two years later, I started missing doing the playful theatricality

that I always loved. That is when I started working on *Magic Frequencies*. It was the opposite kind of balance. Very theatrical, very visual, very colorful imagery. Not exactly characters, but a very episodic piece. I have never presented a concert with the music alone. The music was not the strongest element, it was only part of the visual images.

With *The Politics of Quiet* we could do the whole piece as a concert. I think the same thing is true with *Songs of Ascension*. You don't have to see the images. Being a person who works in these different forms or strands, trying to find the balance of the elements in each piece, is very challenging. I have to go along with what is coming through me, which in the case of *On Behalf of Nature*, seems to be the music. And then, How do you make an image with the music that doesn't take away from the music? That is the hard part of it.

Do all these elements work in a kind of tension?

I try to do that. But that is the hard part of the process, finding the tension, instead of having all the elements do one thing. I try to create a counterpoint with the different elements to make one larger whole. Sometimes a piece will want to have media. Sometimes it won't.

In a sense, what you are saying is that, through your working process, a piece begins to live its own life in the world and tell you what it wants to be.

Exactly. Hopefully, if you are listening. My big thing when I am working is, "Please, make yourself known!" I'm praying. It's "beginner's mind." That's what the process is about.

How does that process involve you? Obviously, you are several decades away from when you started. The pieces are coming from your body. What does it mean to age as a performer? How does the body adapt?

All these questions are really interesting. I think I am lucky in that, since I am my own composer, as my voice changes, for example, I can write music that responds to that. I don't have to do my high E-flats anymore, the way an opera singer has to sing *La Traviata*. I think of Callas. Callas could have been a wonderful mezzo at the end of her life, but she wanted those E-flats. There is a certain image you have to maintain in the opera world. Since I am my own composer, I have always wanted to see what happens to the voice as life goes on. I hope that I can make a piece when I am ninety with whatever instrument I have. That being said, the limitations are not always so easy. Physically, I have to work a little harder to use my body as an instrument that is instinctively telling me what to do.

Do you work at that every day? Do you have a daily practice?

In one way or another, that's continuous. I call it "maintenance." Sometimes the physical work I do more in rehearsal, rather than by myself. Although there is one section in this piece where I am moving full out. It is also a really interesting

section vocally. It's exciting to me to think that I am trying something that I haven't done before. That is what keeps me going.

> *While you are changing, performers voices and bodies are also changing. You have always had highly individualistic people in your work. How is that evolving? What has changed in the qualities of performers you've seen over the decades in New York?*

In my group, I am very lucky that I have been working with the same people for many, many years, and I have seen how they grow. I am thinking of someone like Katie, who came from the classical tradition, and still is a classical singer. But, for example, when we did *Education of the Girlchild Revisited*, given the rawness of that material, she was open to explore the wilder, vocal qualities. It was exciting to go back to that really old material. I see that in working with people who have classical training, sometimes the music gets pretty refined because of their backgrounds. It influences my ear and what I am hearing.

But sometimes I like to go back to that raw quality. All the people in my ensemble are really game. What I notice about some young singers today is that they are trained to be versatile, but sometimes their voices are not as unique sounding. When I began, I wanted each voice to have an unmistakable quality. Maybe intonation-wise and technically today's young people might be better than we were, but that raw and that primal quality is something I think is really important.

It has been said about opera singers, too, that the voices are not as distinct now, so they can work everywhere. Same thing with writers' workshops, where a lot of contemporary writing might be similar. Do you think it is happening with dance, too?

I don't know so much of what is going on with dance. I would imagine that there would be some of the same. It's a technocratic culture. I remember in the sixties talking to Kenneth King when we came to New York. We would be talking philosophy a lot and I remember, in horror, we said, "There's going to be a time when this technocratic thing is going to come in." We felt that we had broken that down and it had been subverted by our work. We were talking about Hegel and the dialectic of that would come in and it would be this technocratic world.

I think that may be true. Even with dance. Dances are highly technical in this country. I find that European dance is more of a depiction of a social world, with less emphasis on a highly developed formalism.

That probably came from Balanchine, who said the subject of dance is dancing. And then Merce picked up on that, too. I think with both of them there are always layers of emotion and oblique narrative, if you want to look at the work that way, particularly with Merce. With Balanchine it is working with music, and that is a different way of thinking. In some of Merce's pieces—I am sure he was aware of it but he didn't always want to talk about it—there seemed to be subtexts in the work.

It's interesting what you say about the raw versus the polished.
As an artist ages, you have more access to bigger spaces, to better
musicians, you get more and more of the things you need as an
artist than when you are starting out.

I don't know. I think the economic situation in this world is
making that get less and less of what I need, and I feel very
much that I have gone back to the early days when I had to pull
a rabbit out of a hat and go to Lamston's 5 and 10 to get my
Slinkys for the show. That is the level I am working with now.
Sometimes I just ask myself, "How am I doing this?" Instead
of having more resources, I have less. There is no money for
production at all. I have to figure out how to create my entire
mise-en-scène just with light and no objects. In some ways,
that is interesting. It is back to that scrappy way of making
pieces and using your imagination to make a piece with no
resources. I mean *no* resources.

But there's also going from Judson Church or Washington Square
Church to being last year in Carnegie Hall and doing the Cage
Song Books *with Jessye Norman and Joan La Barbara.*

I was a performer with the symphony. That wasn't me working
on my own piece.

That makes more demands on you, too, to move into those types
of audiences and spaces, and everything that goes along with it.

I always felt like I wanted to be very flexible. In 1985, I did an entire concert of my music in the big hall at Carnegie Hall. It was a retrospective. I liked that, two months later, I was performing at PS 122. Some artists want to get bigger and bigger and bigger, and when they get to a certain point they only want to play at BAM, Carnegie Hall or Lincoln Center. I was never a person who, reaching a certain point, only wanted to do those large spaces. I was never interested in that. I loved performing *Volcano Songs* at PS 122. It was a young audience. I loved the space, the hands-on feel, and that you didn't have to work with unions. I used to call my work the Schmatte School of Costume Design, the Lightbulb School of Lighting, and the Talented Mongrel School of Performing. I like that hands-on approach. And maybe the next year I'd be up at BAM or at Lincoln Center. I like that flexibility. It keeps you on your toes.

It makes you able to work in all those spaces after all these decades.

You never want to forget your roots. Going back to your roots is very important so you don't get carried away from something essential. Otherwise, you move farther and farther away from the hands-on approach to making art. It is very important to go back to the beginnings at all times. You spiral back.

That is not only a philosophical concept, but also something that is deeply rooted in the making of On Behalf of Nature—*the question of use and reuse. Would you say that an ecological principle informs it?*

I am focusing more on an ecological process, which is something that I've never done before. There is an ecological consciousness in the work. Now I am seeing what an ecological *process* in the work is. As I said earlier, every world has its own laws. So I figured out what the principles of this piece are, and one of them is: You are allowed to take shards or fragments of something old, but it always has to be transformed into a brand new form. For example, for the costumes, I said to Yoshio Yabara, my costume designer for many years, "What would it be like to think about recycling costumes?" My first idea was to go into storage and take out old costumes and use them in a different way. We didn't do that. Instead, we created three color worlds and we asked everyone to bring their own clothing in those colors. Blues or grays was the first one—anything they had. Then Yoshio made a new creation from these clothes.

What I wanted was that, with each person, not only was it their own clothing they were wearing, but everyone had a unique shape and look that very much had to do with them as human beings. The costumes were sculptural. One by one, the performers changed their clothes into a second color. For the second color world, Yoshio took the same shape for each person and reproduced their clothes in a different color range, as if they had suddenly changed from blue to brown. It was like a cinematic lap dissolve.

Repurposing is the key concept to the whole piece. As I said earlier, I also used that same principle with the music. I knew I wanted to have a film element. I thought about three different films, but I couldn't find what the image counterpoint would be to the live material. How many different times are

you saying the same thing? Then I realized, "Why don't we just look at *Book of Days*, the 'Madwoman's Vision.'" It has fast cuts from different realms, the world of nature and that of human beings, and it's all from stock footage. In 1985, that one minute of film took me three months to make. It was so hard to find the right images. Yoshi and I looked at it, and eureka—that montage of quick cuts was the right principle. But by pulling apart the "Madwoman's Vision," restructuring and adding more images, I made a completely new film. It is still all stock footage but more images.

Aren't you describing a principle of collage?

But thinking in terms of repurposing. It is a little different from collage because with collage you are taking old things and making them into a new form, but you are not reusing it again. That's the difference between a live performance situation where you are literally reusing something in a new way.

What are the themes of nature that interest you in this piece?

Of course I want to do something about what we are in danger of losing. But I don't want to be pointing my finger at people. It is not preaching to the converted because the people in my audience know what is going on. That was my quandary while working on the piece. Then I realized that all one can do in this situation is to do an elegy, which is a theme that comes up often in my pieces. *The Games* is a piece like that. In a sense it is like really delving into processes of nature, even invisible

processes of nature. The interdependence of all of us as human beings to cells, to smoke, to molecules, to everything. And, creating something where you have the awareness of that and the possibility of losing it.

The interdependence that you are speaking about, I know it is a great part of the Buddhism that inflects your life. How else do principles of Buddhism, in regard to breath and interdependence and meditation and silence, impact your work now?

When I was a young artist, I knew these things instinctively. Now, I am more aware of these ideas and I try to make work that is of benefit. Beginner's mind—the idea of letting go of everything so that something really new can come through. The interdependency—I always had the idea of weaving elements together perceptually. It was also a reflection of the idea of interdependency of perception and beings. I have become less afraid to articulate that. I wouldn't have articulated it when I was young, but I think I was really doing that.

Was it because of the spirit of the times?

Yeah, I think that I was more afraid of that. Now I think, What do I have to be afraid of? I'm almost dead.

Oh, c'mon…

I guess I was always skeptical that talking about these things would make people think I was some kind of New Age person.

I always hated that kind of talk. It is not very rigorous. Buddhist thought is very rigorous. It is a common misunderstanding that everything is nice and all that. That's a kind of spiritual materialism that I am not at all interested in. That is why I stayed away from talking about it. Now, I don't really care.

That's one of the great things about getting older.

It is! And I think the idea of making theatre and performance is an experience of sacred space. It is a meditative space in one way or another—an internal, meditative space—and you are really giving something when you offer that. It gives people a chance to rest the discursive part of our minds that is going a mile-a-minute, narrating everything that we're experiencing. Trying to drop that for a split-second or having an experience where you can drop that is a very direct experience of energies. People might have one second of seeing the bigger picture of reality. That is really important. Performance is one form where you can do it. Especially music. I think that's why I've tried to stay with more abstract pieces in these past few years.

I was about to ask you how one deals with abstraction or the invisible or the unnamable in a theatrical space. Is that where you are running up against more tension between the musical and the theatrical?

I think it is. That's what I am struggling with right now. I remember wondering if we should have objects in *On Behalf of Nature*. Objects seem too solid. *Impermanence* was an

interesting piece. We didn't have objects at all in the piece, but we did have words. I usually don't use words, but working on *impermanence*, something that was so ephemeral, it seemed like it needed the grounding of words. I used words in an abstract way, but there definitely are words. *Songs of Ascension* did not want words. It was more like some kind of ancient/futuristic ritual of people who have known each other for a thousand years and are going a thousand years into the future. Something like a recurring cycle.

> *What you are saying about the ancient world is very intriguing. I remember the images that were projected and constantly moving on the rough back walls of the Harvey Theater. They had that sense of archaic imagery on peeling walls. It is very much in my mind now because I have just seen Herzog's* Cave of Forgotten Dreams.

As far as the stage production of *Songs of Ascension*, the Harvey was the most ideal space we had. It wasn't quite like that when we were in a theatre where we had to project on a screen or scrim. At the Harvey we projected directly on that magical reddish, old wall. I loved that about the Harvey. I felt like we were looking at cave paintings, or that we were in a Roman ruin.

> *I want to ask you more about the archaic and the ancient. You have always had an interest in old civilizations and artifacts. What comes to mind is* Recent Ruins *and the projection of tools and household items. That is another thread through your work.*

I like the idea of the past and the future. The irony of *Recent Ruins* was that we projected things like a vacuum cleaner head as an archeological object. It has always been this thing of, What will a Martian, two thousand years from now, think that this vacuum cleaner head would be? It always has the past and the future. You can't have a present moment that is full without acknowledging the past and the future in that second. That past is also your parents, your grandparents, and back to the beginnings of time. The other part of it is the future. Each of our moments in life has a combination of those things.

Your films Book of Days *and* Ellis Island *encompass different time periods of past and present, with specific details of the objects used by people in different times and places. There is a sense of looking back into the history of ordinary lives from the view of the twentieth century.*

The genesis of *Ellis Island* is that sometime in June 1979 my friend Louise Steinman called me up and said that she was going out to visit Ellis Island, and would I like to come along? Strangely enough, I had never been there even though my grandparents on my father's side had come through there around 1905. I was very moved by the experience and sensed the ghosts of all the people who had undergone so much suffering to achieve their dream. I first thought of making a site-specific performance there and then realized that the logistics of getting an audience to the island was prohibitive. I decided to shoot a film instead. Since there was no electricity and we had to use available light, we shot a 35-millimeter black-and-white

film so that the images would register. I was very inspired by the conventions and language of still photography of the period.

When I expanded *Ellis Island*, I decided to juxtapose contemporary images of the place, which was a ruin at that time, with the black-and-white images conjuring the past. I shot the contemporary images in color to delineate a clear time sense between the present and the past. At that time, 1980, working with color and black and white in one film was not a common practice. We were obliged to shoot everything on color stock and then struggle to get true black and white images that didn't have a pink, yellow or bluish tint in the print.

I used the same technique in *Book of Days*: color indicating the present, black and white representing the past. *Book of Days* was really a time travel film dealing with the similarities and contrasts between the Middle Ages and contemporary life. In the film, contemporary television reporters interview the medieval characters, and the main character, a young girl from the Jewish community during the time of the Black Plague, has visions of our time. The impulse for displacing time in my films is to allow us to look at our own reality and at things we take for granted in a new way.

In a sense, you've encapsulated a hundred years of what people have said about the past and present. I'm thinking about T.S. Eliot's classic essay, "Tradition and the Individual Talent," where he talks about the pastness in the present. Zoom ahead a hundred years and the Italian philosopher Giorgio Agamben, in one of his influential essays, writes that contemporaries are people who recognize the archaic in the modern. And also that

the contemporary is the one who can transform all these dif-
ferent times and put our time in relation to other times. My
question is, What is the nature of time in your work?

Oy, oy, oy. Oh God. Thanks a lot.

You work in musical time and performance time. Let's talk
about time.

I am interested in different aspects of time. One of them is his-
torical time. Archeology and layers of time is something I have
always been interested in. Digging back through to something
else. And then I am always interested in time as a sculptural ele-
ment in a performance, that you can stretch it and compress it.
Time itself becomes an element. Certainly rhythm has always
been very important to me. Not only the rhythms in the music
but the rhythm of a piece is a primary element in my work. I
come from a musical background. Of course, I am going to
use time as the most important element. Time and space. It
is something that I work with very consciously. I try to work
with it in a very plastic, fluid way. The structure is one of the
concerns that I have. Is the structure fluid? Is it percussive? The
way that one event comes from another event, or doesn't, is
very important.

Has your view of different forms changed much over the
decades? How is time itself changing the way you look at many
of the elements you work with, for example, imagery, or music?

I try to follow my inspiration and I try to follow my path as best as I can. One of the things in this path that has been really interesting to me is that the music has become stronger and stronger. The music itself has become a primary element. In a way, I was freer theatrically when the music was only one element and I didn't consider it stronger than any other element. For instance, I am thinking of a piece like *Vessel* where there were whole sections of silence and the rhythms were in the activities rather than the music. Now, because my inspiration seems to be music, that imposes a time structure I have to work with and figure out.

One of the things I am doing with *On Behalf of Nature* is that I am having moments of silence, so there is a counterpoint. It is not moving from one piece of music to another. Also there are different modes of sounds. Some sections are music with keyboards and voices and everything, and the other instruments that we are playing while making a cappella vocal sounds, and then there are sections I am calling "Washes," where we are all walking and it looks like a task. As we walk we are making patterns on the floor, say, like a bee hive. You wouldn't know what the references are, you don't have to know. The vocal sound that we are making isn't corresponding to that particular pattern. Within one piece, there are different modes of musical perception, and then modes of silence. I am following where the music wants to go.

I want to go on learning throughout my life. Every piece is like going to music school. I had some music training but I never went to conservatory. For some of these problems that would be solved easily by someone who went to conservatory,

I'm like, "Wow!" I am working with these chromatic, strange, dissonant scales, and for me that is very exciting. It is new for me.

> *Do you think the prominence of music is related to grief or emotion? You have had enormous personal changes in your life: the loss of your partner in recent years, and then your mother.*

I think that none of us, unless we have experienced what it is like to lose someone very close to you… I just didn't know. I think, as a young artist, I was in touch with some source that was beyond my years. Doing something like *Education of the Girlchild*, I played an old woman. Why I was interested in that at the age of twenty-eight I have no idea. The piece I sing in it is a kind of dirge. I was very aware of the sadness of the world, but when you have an unexpected loss, I think you are never the same after that. When I discovered my vocal work in the sixties, I knew that something about the voice was connected to an emotional source that was really important to me and really direct. The danger of some of my work in the early days was that it could get a little intellectual. Once I found that vocal work, I knew that was where it was: the core of human expression, not only for me, but for all of us as human beings. It comes right from the center of our being. The voice has that capacity to delineate energies for which we don't have words. You are in touch with something else, with the absolute beginnings of utterance. Maybe it is true that because of the losses in these last years, to try and make narrative now, or even characters—I don't know, it is almost too coarse. Music is finer.

It is strange to me that somehow after that experience I have gone more for an ephemeral, mysterious sound. That seems to be the way I am going. I see that all the images I am thinking about are right in the music. What do you do on top of that, when they are in there already? It is a real transition for me. I don't know if this is the way I will be going for the rest of my life or if it is just now. In a way, I am contending with it because there is a part of me that says, "Been there done that" with characters and objects. Isn't that strange? I am having a hard time finding something new with that, although there is a section in *On Behalf of Nature* that is a solo where I feel like I have never done anything quite like it. It's like a rant, a non-verbal rant.

> *You are making me think of John Cage speaking about the wonder of bringing "new things into being." The question is, How does one do that? What are the new things that occupy you? That is what I was intimating when I asked if the world is a different place now after your personal loss?*

I don't know how to address that, but I feel that what I have gained over these last ten years is the awareness that I really don't want to separate my spiritual practice from my art practice. The process of making a piece is a process of contemplation. I want to always make pieces that can't be made. How do you make a piece about "mercy" or "impermanence" or "on behalf of nature"? It's impossible. Sometimes when I am saying, Why did I take on *On Behalf of Nature*? I say, I did take on *impermanence*. You are not going to come to an answer or

conclusion but it is taking the time to examine something. What else do I want to be working with? That is always the waiting game.

It is always difficult to start with an empty space or blank page. How do you free yourself to move into the unknown? How do you balance between the absolute fear of that and the confidence you have after all these decades? You have your skills, your technique, and know how to work with them.

I always say that the fear is overwhelming at the beginning. It's like jumping off a cliff. You have absolutely no idea what is going on. It is like being a detective. You try to follow every clue that comes up. Some of them are McGuffins, but I think that is what the process is. It starts out with fear, and I think that's a good thing. If you know what you are doing already, what is the point in doing it? It is always like hanging out and tolerating the pain and the fear of the unknown. Then usually what happens is that a little something will come up. If I am sitting at the piano—I remember sitting at the piano and almost shaking at the beginning of this piece—one little phrase will come up. And then you get a little interested in that one little phrase. Or I say to myself, "Step by step." Another thing I say to myself is, "Remember playfulness, Meredith?"

What happens at a certain point is that the thing itself starts coming in and you realize that you are more interested than you are afraid. You are in this thing, whatever it is, and fear is useless at a certain point. But at the beginning, it is not so bad. It is saying that you are risking. I think that taking the chance

on risking is something that keeps you young. I'll tell you, what you are saying about my skills—I don't find it easier. It is just as hard as it ever was. I don't think, "Now I have these skills." I don't think in those terms at all.

Can't you rely on technique after a while?

I don't think so. When you are making something new, you aren't going to be able to use the same technique that you used on something else. Maybe other people think it is easier as they go along. I think part of the challenge is *not* to rely on things that you know, and to keep on listening. It is really a process of listening to what something needs. What's right for it.

(JANUARY 1, 2013)

Meredith Monk, 2014. Photo: Julieta Cervantes.

On Behalf of Nature, 2013. Photo: Julia Cervantes.

Cellular Songs (showing of work-in-progress), 2017. Photo: Julieta Cervantes.

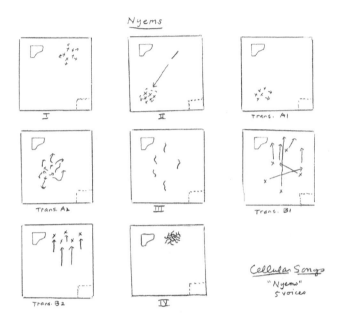

Meredith Monk ground plan for "Nyems" from *Cellular Songs*, 2018.

Meredith Monk receiving the National Medal of Arts from President Barack Obama, 2015. Photo: Leigh Vogel.

III

What is the significance of the title of your new work, Songs of Ascension? *It has an obvious reference in terms of Judaism to* The Songs of Ascent *and also to Christianity, which celebrates the Ascension on Easter Sunday, forty days after the Resurrection. There are Buddhist references as well. How did you arrive at the concept of "ascension"?*

I think the best way I can talk about it is just to tell you a little bit about the process of how the piece began. The generative meeting was with a friend of mine, Norman Fischer, who was originally the abbot of the Zen Center of San Francisco. He was born Jewish, spent many years doing Zen practice, and now he has come back to also doing a meditation practice for Jews. So he is definitely trying to integrate these two things. We were having a conversation—this was many years ago—and he was talking about the poet Paul Celan, whom I had never heard of. Paul Celan referred to the Songs of Ascent.

Now, I might have heard it wrong, because I thought I heard it as Songs of Ascension, but it was really Songs of Ascent. They are psalms from the 120th to the 134th. People from all around an area would come to a mountain, they would bring their best harvest, and they would recite or sing these songs going up the mountain. There were fifteen steps that went up. Apparently, at each of the steps one of these psalms was sung. Now I didn't know all of the details of it but

something intrigued me, and I was thinking—isn't it interesting, first of all, that so many cultures go up to worship? Why is up better than going down? I was intrigued to know what those songs would have sounded like—and that idea of walking up and singing. I started thinking about other cultures, like the Mayan culture, the Inca culture, and in Buddhism there are stupas that you go up as well as the circumambulation aspect of going around them.

I wasn't thinking of the Christian Ascension, to be totally honest with you. But certainly all the churches go upward. So in a strange way, I was thinking very sculpturally and very dimensionally of what's up and what's down, and what's around. I was contemplating that and something felt right about working on it. Then around that time Ann Hamilton, whom I had just finished working with on *mercy*, said, "I'm working on this tower [*tower · Oliver Ranch*/2007, a concrete tower measuring 80' high and 24' in diameter, in Geyserville, California] up in Sonoma County, and I would love you to sing for the opening of the tower." So that was in the back of my mind. Then I started working on a string quartet for Kronos called *Stringsongs*. Usually when I am between pieces I have a lot of different ideas. Sometimes, part of the beginnings of working on a piece are weaving together some of what would seem like disparate ideas. We went to sing at the opening of the tower, and did repertoire from many years. I only brought five singers with me so there were no string players, and we basically did a very simple and direct piece to see what the acoustic situation was.

How did all these elements work within the tower?

I was trying to bring together three ideas: the string quartet, Ann's tower, and the *Songs of Ascension*. It seemed that with the *Songs of Ascension* and her tower there was some synchronicity. I went to her and I said, "I'm working on this piece called *Songs of Ascension*, and wouldn't it be interesting to try to work with the tower as one aspect?" I had not seen the tower at that point, so I had no idea how difficult it would be, actually.

There is one other thing I want to tell you about the tower. What I find very inspiring about working with it is that the inside is a double helix of stairs that go up to the top, which is open to the sky. I started getting very interested in DNA and the helix as a structural idea. If you have not seen the tower you might not know that in the way the piece is put together. But if you have, you actually feel this internal musical spiral weaving and threading structure, within the passages, and also within the structure of the whole thing. So that's an underlying inspiration.

Do you mean in terms of the biological?

It is more that the idea of weaving and strands and the way the DNA is a three-dimensional kind of weave. Musically, what was very interesting for me to work on was to think— how would you make a structure that was like that, where the musical phrases would connect to be a continuous spiral? But then there could be these side connections. Because if you look at DNA, there are all of these little connections that are going in a different dimension. So how would you actually make a musical form that was like that?

*It is not the kind of tower where you look out over the landscape
but more like an acoustic space, isn't it?*

Well, as I said the top is open so you can see the landscape
all around it, if you are at the very top. The interesting thing
about the double helix that Ann created is that instead of it
weaving around the way that you usually see a double helix, it
looks likes the stairs are sometimes going in parallel, but then
they start weaving in another dimension. So you could be five
feet away from someone and think that you are right next to
them, but you can't get to them. The windows are more like
window seats. They are like little alcoves. Sometimes we will
use them to put the instruments there, and sometimes people
will be in those alcoves.

Let's talk about the evolution of Songs of Ascension, *starting
with the first version at Dartington College of Arts, in the
Great Hall of the school, in Devon, England. There it was
more-or-less a concert version, performed with the lights on. The
audience was on two sides and the musicians in the space at
one end of the room.*

It was at eleven o'clock in the morning so it was all natu-
ral light coming in the windows. I love the idea of people
performing in the day. People just come in for the piece and
then they go on and live the rest of their day. There is a little tiny
platform, maybe six inches, and that was kind of a natural place
for the instrumentalists to have their home base. We had only
worked with the Elysian String Quartet for a week, so they

had not memorized the material. They were reading some of the material on music stands, so it became very functional. In the more theatrical version done later at the Walker Art Center in Minneapolis, the string players memorized all the music, and so they could move throughout the space in different ways.

One has the sense that the performers are performing for each other as much as for the audience, since the musicians and singers and dancers are in the same space at times. I have the feeling that in some of your pieces there is more a sense of a community than of a cast.

That's exactly it. This piece is not really meant to be a theatre piece at all. You could say it is more like a ritual or an offering. At the Walker we have the house lights on the whole time. And I remember someone said, "Oh, you know, maybe I would have liked to have had the lights go out so we could go into that world." And I said, "You and that world are the same world." That was a conscious choice. What Ann has done visually with her videos is that she has the videos on turntables. So the video is also slowly revolving around the audience and coming across the space. In a way, what Ann has done, and what we talked about right from the beginning as a concept, is that all the other elements except for the music are really like weather. The music, the movement, and the interactions of the performers create a sense of community and the audience is immersed in the experience.

Weather is a very interesting concept—the climate or the envi-
ronment of the work. How else did you think about it?

It's like the sun coming in the windows. We don't have the sun
coming in the windows in a theatre, and you are confronted
with a black floor. At the Walker we took all the wings out.
In most theatres we are going to try to do that as much as
we can. We'll get it down to a totally naked space as much as
possible.

How did you change the piece from the more concert-like ver-
sion in full light in England, which didn't have any of Ann's
elements yet, to the theatrical version in the U.S., which also
included her video?

Well, we had talked about working together on this even before
Dartington. We were scratching our heads thinking, What are
we going to do in the theatre? How are we going to animate a
theatre and get away from a pictorial, frontal kind of orienta-
tion that a theatre necessarily has? For a while I was concerned
about the particular images that Ann was going to use, and
how they worked in terms of content. What ended up hap-
pening was that she realized that in a way the content of the
images—and I realized this too—the particular content (the
horse, the bird, for example) was not very important. Ann
chose old black-and-white found footage, which she thought
would work visually; I thought that was a better way to go. I
originally thought, well, you know, the horse should be in this
section, and this should be in that section, and we didn't really

technically have control over the turntables. It depended on when, for example, you started those turntables and when the audience came in. I remember that at a certain point I finally realized: just let go of all this. It is like an installation piece. It should just have its own reality.

You talked a little bit about how video affected your process. But what does it bring to the piece?

I think it brings this piece a constancy of cycles because you are literally seeing these images circle around. It animates the space itself so that I don't have to have people moving around all the time to have a sense of movement. It allows you to rest. This is the weather that is going on, and you can rest in that. Then you can really listen to the music.

Weather is essentially an atmosphere then.

Atmosphere, but it also suggests recurrence. The videos create a sense of space and a different time cycle in counterpoint to the music.

Since you also collaborated with Ann in mercy *what were the kinds of lessons that you learned in terms of working together? What did you bring to the new piece from the experience of* mercy?

I think of this piece as a different process than *mercy*, because in *mercy* we started working together conceptually right from

the very beginning. This time, I spent a lot more time making the piece without her input. I mean, we'd talk on the phone from time to time and we'd meet. But it did not have that sense of the two of us really starting from the same place. In a way, it necessitated independent contributions. For me, letting go enough, surrendering enough, to actually realize that sense of another independent layer having its own integrity, as my musical structure has its own integrity, is interesting. I usually don't work like that.

It sounds more like the Cage/Cunningham model of autonomous languages that nevertheless work together in an organic way.

I feel as though the form is very organic, the structure is very organic. My process of making my material was very organic within itself. And then I have to trust that that other element is going to also have its own integrity. Yet, at the same time, it is actually like thinking of counterpoint; a visual, temporal counterpoint. What is very interesting to me about this process and working on *Songs of Ascension* is that it reminds me a lot of some of my older work, like the process of making *Education of the Girlchild* or *Juice*. It is a modular way of working where the components can shift or change in every situation. And so for me it is very exciting to go back to that way of thinking. It's like a vocabulary that can shift in different spaces. For example, performing the piece in the tower will have to be a whole different structure, because there are some things that we can't do in there.

So there will be three versions of the same piece.

Three, and maybe even more.

You spoke earlier about the cyclical nature. How would you describe your notion of time? There doesn't seem to be any historical time in this work.

No. The piece is quite abstract. It really has a primordial sense of time: seasons changing, for example, and different speeds of change. Time circling around, cycles of different speeds and dimensions.

I am interested in how a work that has liturgical or spiritual connotations, in terms of ascension, manifests itself in the meter of a musical composition.

Wow.

On a purely technical level, how do you treat the voice and movement and image in space to achieve a kind of luminosity?

Songs of Ascension is music driven, but I think of the whole thing as a composition: how to weave together or distill the perceptual elements. Does gesture take away or add to the music, for example? This is one of my fundamental questions. On a spatial level, I would never be limited by something like having to ascend all the time. There is a lot of downward movement in the piece as well and circumambulation. It is more

of a sculptural idea of up and down. I was curious about why in ancient forms of worship the impulse was to always go up. Why didn't the participants go down into the ground?

> *As a matter of fact, what is interesting to me is that at the end the performers are rooted to the earth because there is the unusual image of the musicians lying down with their instruments on top of their bodies. Whereas, if you think of an earlier work, like* ATLAS, *the performers are clearly going up a ladder.* Songs of Ascension *is a different kind of resolution. It is not quite there in that idealistic realm but more earthbound and unresolved.*

There is another layer. I don't think it is very explicit, and I am not sure how to work with it, but when I was beginning this piece I was contemplating how to reflect my ongoing interest in ecology. I had just finished reading Cormac McCarthy's *The Road*. The image that I have at the end when I am singing, crouched down with the shruti, is that I feel like I am this ancient, three-hundred-year-old woman actually boring down into the ground. It is this idea of a memory of the earth—like the earth is finished. It has that kind of sadness of, you know, oh yeah there were geese, and oh yeah, there was an earth.

> *Yet, none of the versions of your piece have the sense of a catastrophic imagination, or what I would call the post-cultural imagination of* The Road.

No, no, no, that is very specific. Some of my earlier work, like *The Games*, had much more of that, and *Turtle Dreams Cabaret*. But in *Songs of Ascension*, there is a pull between the absolute and the particular. There is not just sky, there is also earth: earth, sky, and human.

You know what struck me… I don't know if you have this feeling but it seems to me the shruti is like a book.

Oh, I never thought of that.

When the piece opens, there are three of them on the floor. So, they're another element of your work where objects seem to have their own life.

Exactly.

They're not props. They're not even always used. They exist in the space.

And sometimes we bring them in and out. At Dartington we left them in the space the whole time. At the Walker Ann objected. She didn't like them in the space the whole time for this piece. She felt that space should open up sometime. So what we have been doing is that we bring them in and out, and that becomes another kind of cross layer that doesn't necessarily correspond to when they are going to be used again.

*But I thought of them as books that you read. You are playing
as if you are reading.*

That is so interesting. I *love* that. That's beautiful.

Is the shruti a kind of harmonium?

It is not only one note. It has chords, basically it has clusters.
I think that Indians probably play it more front-to-back. But
I am more comfortable playing it sideways. The position of
crouching over it is comfortable for me.

*How have the musical ideas evolved in relation to the differ-
ent spaces?*

My earliest musical idea was to work with voices, strings, reeds:
all instruments that could be portable. The tower environment
would not allow for keyboards, marimbas, etc. This was a limi-
tation that was fascinating to work with since so much of my
music has piano or keyboard as an integral part. Then I thought
of breath: the connection between singing and meditation prac-
tice, where we always come back to our breath. In *Stringsongs*,
the third movement is *Obsidian Chorale*, where I have writ-
ten a series of chords that the string quartet bows in unison so
that the strings seem like big inhalations and exhalations or a
giant accordion going in and out—bowing as the equivalent of
breathing.

I wanted to continue further with that idea, and when
Ellen Fisher gave me a shruti to play with I felt the connection

of that to the movement of the string players, our breaths as singers and the wind instruments. Then as a contrast, I added the percussion—the only struck sounds in the piece—but I told John Hollenbeck that all his percussion instruments had to be portable. He came up with some wonderful small instruments and we made a harness for him to move with them.

So many of your pieces—mercy, impermanence, The Politics of Quiet—*move in the realm of the spiritual. Aren't you striving for the transcendent?*

Yes, I am, but I am also trying to wake people up. I am striving for theatre as a transformational experience and also as offering. So yes, those aspirations are there. Ascent just means you go up. But "ascension" also refers to ancestors. I feel that work like this needs to have a kind of rigor and lucidity to it, but the piece is strangely enough put together, and has enough mystery to allow each audience member to respond in his or her own way. I certainly am not trying to illustrate ascension. The abstraction allows your mind to be free. I do not want to manipulate my audience in any way.

Last week I saw The Passion of Simone, *a new oratorio by the Finnish composer Kaija Saariaho, with Dawn Upshaw, that was based on the life of Simone Weil, and directed by Peter Sellars. Having just seen that work and heard yours back-to-back it seems to me this turn to spiritual subject matter has brought an elegance to contemporary theatre that has previously been lacking. Of course, when one hears music like this,*

Messiaen comes to mind for his deep spiritual feeling. Now we know that he was rooted in Catholicism. Your music and the Saariaho composition represent more of a kind of secularization of the spiritual.

Well, I think that the world we are living in now desperately needs to have experiences that are direct, that are not filtered by discursive thought. Our culture is built on encouraging indirect experience—you either evaluate it or you narrate it. All these devices that are in our culture, like the computer, television—the speeding up of experience, the fragmenting of experience—are designed to distract you from direct experience. So everything is like secondary experience. I think that live performance gives you that possibility of actually having direct experience, slowing down time a little bit, which I appreciate very much, and I think of as an antidote. I don't know if I would say exactly the "secularization of the spiritual" because I think Buddhism itself is a non-theistic practice. My thinking for many years has been, Why do we also make a separation between art and spiritual practice? We don't think of art anymore as offering. There are so many cultures where it is totally integrated within daily life.

I use that term in a post-religion sense because I know many people are very uncomfortable talking about religion.

Religion and spirituality are two different things. I think religion does imply a theistic kind of thinking, whereas spirituality is more inclusive.

Is that the issue for you: the monotheism that you react against?

Coming from a Jewish background I have a strong reaction towards any organized religion.

Yet, Judaism, is a strong element in some other well-known composers, like Steve Reich and John Zorn. Philip Glass turned from his Jewish background to Buddhism. The spiritual is a major impulse of their work.

I just feel that it is really important in this world to know that we are not the be-all and end-all of existence, and that there is a larger picture that we need to keep in mind. And, you know, there is a sense of magic that we are losing. Another thing I love so much—I've said it many times about live performances—is that we are in the same moment in the same space. There is a congregation of human beings, including human beings who are performing and, in a sense, are so vulnerable. That level of communication is very important in the world that we are living in.

In the Dartington setup, where it was a very raw and pure performance situation, there was more of a congregational setting. Whereas the version at the Walker, and perhaps any future versions, will be more audience-oriented.

We're trying so hard to work against that. There were people in the audience who said, "We felt like we were just part of this whole thing." How do you get people out of that audience

situation to become a congregation? That is one of our main questions we have been struggling with ever since we realized that we were going to have to do the piece in a theatre.

Is there a certain desire to move away from theatre or the theatrical?

I really want to move away from the theatrical in this piece. I just don't think it is appropriate. I think that the piece is very abstract and not pictorial. It is much more a piece about experience. It is more open-ended and has no narrative at all. Basically, I am trying to make a situation where all the senses are stimulated but you still have a lot of space to hear the music. You know, that is one of my biggest concerns. Not to get in the way of the music. That's why I have been very simple in the staging.

What you are creating is chamber music, and, more recently, symphonic music as well. A kind of contemporary classical music that is also highly virtuosic and refined. Earlier I used the word "elegant." As you move more towards this musical development I am interested to know how it is technically manifest in the bodies of the performers, in certain movements, and choice of imagery. There is something in contemporary music that is giving off this spiritual quality, and what is that to you?

In this piece I was very aware as I was making it that some of the music seemed to be very ethereal. I tried to make a balance of that with some of the more raw elements like the "Calls"

section, and that little trio that I do with Allison Sniffin and Todd Reynolds. Heaven, Earth, and Human—those three realms are needed to represent balance. Balance is something that I always think of in my work. I don't know if you remember when we were standing in the circle. I call that line "Strand 1." I was thinking a lot about lines. It had to do with the tower and the threads of DNA. It is strange that I am speaking of the biological, but it refers to microcosm and macrocosm.

So physiologically the music is felt in the body, which responds, in turn, to space? Can you elaborate on that?

Well, for example, the end of the piece is a procession and that music was the first material I made. A procession usually implies walking. I realized that walking relates to either a 2/4 or 4/4 meter—both are even meters, which also relate to heartbeat. Usually I prefer to work with uneven meters, such as 5s or 7s. When I tried to add asymmetrical meters to the procession, they canceled out the movement of walking. There are other parts of the piece that have irregular rhythms that relate more to breathing and blood circulation. In the passage called "Falling" the strings do a very long *glissando* gesture passing the notes from one instrument to the other so you can get a sensation of the energy actually going down. Then the voices take it. The actual physicality of the space influenced the way I composed the music.

A lot of the inspiration of how I voiced the music had to do with thinking about how to utilize the sound in the tower. For example, in the tower we will not be miked at all—the

acoustic is very live and that influences my musical choices. Overall what I was working with was, How do you make a form that is not built of separate sections? How do you make a structure that is an hour-long continuity, where the elements reappear in different contexts and weaves, forming and reforming a thread or line?

> *Speaking about the line... that is something Kandinsky wrote about, regarding the spiritual in art—there are certain kinds of lines and colors connected to abstraction that lead the way to a certain kind of thinking. I feel the same thing exists in music. What is it that transports one? How is it felt in the body? For example, there are rhetorical styles and forms that lift language in different directions. I guess I am trying to put you in the mindset of, say, Edgar Allan Poe when he tells in "The Philosophy of Composition" exactly what he did formally in "The Raven." He did this, because of this effect. He did that because of that effect. I am interested in what a composer or director or choreographer does technically to create certain kinds of effects.*

I never think that way. That's more a critical after-the-fact kind of thinking. I actually just burrow myself into my material, and try to solve the challenges that come up in the process, those internal problems of structure and of the key relationships. The narrative of the music has its own developmental clarity and integrity. I never think what the effect is going to be. I just go right into the material and try to deepen my understanding of it.

Well, it is clear that the work is also becoming more emotional year by year. Do you have any thoughts about that?

I know what you mean. In *Songs of Ascension*, you can feel this underlying... I can't put my finger on it exactly.

It's poignant and full of feeling.

I know, but then it's a mystery.

I go to performances constantly. They're mainly illustrative of the social crises that we are undergoing. There is very little work that has an emotional quality to it. As you know, emotion, beauty, and elegance are not much in evidence in the vocabulary of contemporary work. People are concerned with what the politics of work is.

I think a lot of it has to do with my meditation practice. My aspirations are very different now. I have worked all these years—forty-five or forty-six years—and now I just feel like I want to do something of benefit. The political work is really interesting but it also is very limited to its time. There was a period when I was working on *The Games*, *Recent Ruins*, and *Turtle Dreams Cabaret* that I was very interested in stating the problem.

At a certain point I don't think people can actually work with that. I am really more a poet; I am not a political or analytical writer like Brecht, for example. I can only offer a perceptual experience since my work is primarily non-verbal.

In this society where we are continually diverted from the moment, where everything is being numbed, I feel like performance can wake you up to the moment. All we actually have is the moment.

That comes from your Buddhist practice. Is the work always an aspect of spiritual practice—is that the way you think of it now?

I do. Absolutely. Oh, I am definitely trying to practice more because I don't know how many years I have left on the planet. You know, I had a big loss in my life, and so I am certain that I or a loved one could just drop dead at any moment. That realization was the inspiration for *impermanence*. When you are working on a piece like *mercy* or *impermanence* you are contemplating something and asking questions that you know you don't have answers for and you never will. With *Songs of Ascension* I think it has to do with affirming certain human aspirations that have existed through all time. It's cross-cultural and has involved millions of people. I don't know how to say this exactly...

Yes, we don't have a vocabulary for that. That's why it is hard.

We *don't* have a good vocabulary for that. When I was a young artist, creating *Education of the Girlchild* or *Vessel*, I was working on that level in those days too. I feel like my work always had that. But I think now I am a little bit more aware. At that time I just assumed it, or came to that approach instinctively, and now I feel like I am not afraid to do it. In our culture

there is a kind of pressure of not articulating these things. Do you feel that too?

> *There is a drive toward documentation, toward replicating global crises, to feel you are making a contribution. On the other hand, there is a great desire for people to have experiences that are ineffable and full of feeling. We have few of them in the artworks that are now created.*

And feeling and emotion is not the same as sentiment. Real emotion—we don't even have a word for it. It is not anger, sadness. It is like subtle shades of feeling or energy. There is just not a lot of work that addresses that. Another thing Ann and I have in common as artists is that we are both really interested in exploring the unknown and exploring the nameless. You know, if you could name it, then it is not really that interesting to work on. And that's why this interview is really difficult for me to get through… I can't talk about this very well.

> *The avant-garde started with symbolism, with silence, and the return to new spiritual movements, and also the idea of not naming things—tower symbolism, too. Here we are more than a hundred years later. Do we know what "the spiritual" means?*

I have so much skepticism about that. It's like, "Ahhhhh, I don't know."

(AUGUST 19, 2008)

Education of the Girlchild: an opera, 1973. Photo: Lois Greenfield.

Book of Days, 1988. Photo: Dominique Lasseur.

IV

When did you first feel you had begun to realize your vision and sense of self as an artist?

When you are a young artist in your twenties—at least, for me, it was that way—it is a life and death search for artistic identity. When I was at Sarah Lawrence, I had glimpses of the possibility of putting together different forms or interests, so I started making performance collages of image and object, with a little singing or gesture. But they were just attempts at that idea. The first time I felt that I had found the way to make a poetry of the senses was *16 Millimeter Earrings*, in 1966. That was the first piece where I made a whole vocal soundtrack, it was the first piece where I used film, the first piece where I used objects as themselves. I was thinking of the whole space as a canvas. I was thinking about painting and materials in a fluid, plastic way, and using physical materials, as in paper and hair, and objects as texture and forms, in a conscious way.

My idea for that piece was that every realm was a world. I was working with the world of movement or gesture. I was working with the world of the voice. I was working with the world of text. I was working with light. Texture of costumes, costumes as texture, and weaving them together in a very complex form. That was incredibly fulfilling. I felt like I found what I had been looking for a long time. I was working with myself as material. I was working with my body, my hair. I could use

anything in my life as material, but then I objectified those elements and turned them into images that only referred to themselves.

After *16 Millimeter Earrings*, I was flailing about again. I was thinking, How do I go on? How do I grow from this? One of the things that happened, right around that time, was that when I sat at the piano I had a revelation about the human voice and the voice as an instrument. I wanted to delve more deeply into the voice as character, as landscape, as image, as a way of producing sound, as a physical instrument, and so that was the other part of finding the depth of my identity. Those two things were how I found the two branches of my life tree.

You started out with theatrical and cinematic landscapes, and have moved, in recent pieces, to a much more musical landscape with much less theatricality, even though you are performing in big theatres, as in recent works such as On Behalf of Nature *and* Songs of Ascension *or* mercy *and* impermanence. *What was the process of this evolution? How has musical composition seemed to have taken over from the earlier work, which was very rooted in visual and cinematic arts?*

There has been a growth in my music making as I've been interested in exploring elements most composers learn in music conservatory. It is more the exploration of instruments and their colors and the landscapes you can make in music itself that has been part of my challenge: How do I make these other elements balance? Part of my search in each piece that I make is the balance of elements. Sometimes I don't know what it will

be until each piece is finished, and what the particular form is. For example, with *The Politics of Quiet*, I came into rehearsal with a lot of the music intact. I had a wonderful ensemble at that time of ten fantastic singers. I was trying all kinds of theatrical ideas that would be in counterpoint to that very developed music. But the piece didn't seem to want it. A lot of it is also asking the piece, What do you want?

That's why it is very interesting and also challenging that I don't do the same form every time. Each piece is making a world in itself and exploring the form and the principles of that world. I have to listen very carefully to what it wants and what it does not accept. Even if I love a piece of material that I think is great, maybe that is not part of the world that is being delineated by this particular piece. With *The Politics of Quiet*, we tried so many different theatrical images and situations. Little by little, it pared itself down and when we finished the piece, I thought of it as a kind of oratorio. There was still a movement element. The piece was very much about community. I remember you talking about how it was making a new kind of community. It wasn't just a music concert. That is what *On Behalf of Nature* has turned out to be, too. It became a group of people doing a rite or a ritual that is conjuring energies of the universe, natural energies, to bring them forth in a way to feel what it would be like to lose them. It is very pure.

I want to stay with that idea. You see that in Recent Ruins, ATLAS, *and particularly in* The Politics of Quiet. *The performers are singing, dancing, and enjoying themselves as a group. Or grieving, becoming very somber. You also have as an*

ongoing spatial configuration in the use of the periphery of the
performance space. That is very interesting. In many of your
pieces, performers sitting down or standing around the periph-
ery of the space watch other performers.

There are questions that I ask every time that I make a piece.
One question is, Are there entrances and exits in this piece?
The Politics of Quiet only has one exit in the whole piece, where
everybody goes out, but basically everyone is in the whole time.
Same with *Songs of Ascension*. That is what creates a sense of
ritual rather than a theatre piece. *On Behalf of Nature* is dif-
ferent. We go in and out. The form shifts, and we don't watch
each other. That question is one of the early questions. Is there
furniture or not? Are we onstage for the whole time or not?

Does that make a rite or a ritual, whether you are onstage for
the whole time?

It can contribute to that feeling. In *Songs of Ascension*, that was
the beauty of the piece. The earliest performance of it was in
Ann Hamilton's tower. To get in and out was a major process.
You had to crawl in through the doors. I realized I was not
going to get forty people in and out of those doors, and I had
to figure out a staging. When you are not performing, what are
you doing? That worked its way into the stage performance,
where we had those beautiful little stools and we were watching
each other. There was something refreshing about the lack of
entrances and exits. After *The Politics of Quiet* I was missing the
playfulness of working theatrically. One thing that I decided

was to ask Lanny Harrison to be in a new piece because she was an actress and not a singer, really. I made the piece, *Magic Frequencies*, which I called a science-fiction opera. It had different vignettes. Visually, I thought it was very beautiful. The lighting was by Tom Hase and the costumes were by Gabriel Berry. *Magic Frequencies* are the frequencies that are in the universe, attached to the hydrogen element. There are scientists who are sending radio signals out in space and they think that, if there is an intelligence out there, it will receive the messages in the hydrogen molecules because hydrogen is the most prevalent element in the universe. Fifty years from now, we might get an answer. So, the piece is very surreal and it is about these seemingly simple vignettes, but there is always something underlying that is a little off or a little mysterious and comes up out of the cracks.

Thinking of all my pieces as a visual artist, one of my first approaches is that once I've got the spatial configuration, I've got the structure of the piece. With *On Behalf of Nature*, I couldn't figure out what the structure was until I figured out the space. The space is divided into horizontal zones differentiated by light. The front zone is the "ritual zone." The back is called the "memory zone," and the big space in the middle is called the "field." The configuration of the instrumentalists all packed together is called the "island." Once I have spatial configuration, I have an anchor in my thinking. I am on my way to getting the time structure. Time and space structures are very linked.

Do you draw the configuration first?

I often draw.

How do the drawings relate to your process?

I draw to clarify my concepts and to get an overview of the piece that I am working on. I make different kinds of drawings for different pieces—maps, charts, line drawings, watercolors. It is a way to organize my thinking and to find the spatial configuration, the atmosphere, or the vocabulary of the world that I am exploring.

Your earlier mention of zones in On Behalf of Nature *leads me to one of your great works—*Quarry. *How did that evolve in the mid-seventies from pieces that were site-specific in different spaces that you would physically travel to, like* Vessel, *to different zones within a single space, as in* Quarry? *How did you make such a leap to have a historical narrative and five different spaces in a mandala form, and a film in it, as well?*

I had used film from the sixties on, but, starting from *Vessel*, I was trying to play with adding layers of actual historical or narrative content. *Vessel* was a huge, three-part opera epic with Joan of Arc as an archetypal character that wove through a giant tapestry. In that piece I was thinking about tapestry as an inspiration for abstract form. With *Quarry*, I had toured in Europe in 1972, where I had done the *Education of the Girlchild* solo for the Nancy International Theatre Festival. Then we also did a version of *Vessel* in Liverpool, including one hundred Liverpudlians. Part Three was in an outdoor railroad station site

with skinheads throwing eggs at us. It was amazing. My first time in Europe was in Alsace-Lorraine. I had always been fascinated by the two World Wars, and I was noticing there weren't a lot of men from the ages of forty to sixty. I saw women that age, but not a lot of men. I asked about it, and they said "Well, a lot of the men were killed in the war." Then I started pondering what it would be like to be in a country where a whole generation was lost, and to be in a country that was occupied. What would it be like to be an Eastern European Jew? Even if I were a great artist, I would still be a number.

I started studying and reading. I read *The Rise and Fall of the Third Reich* cover to cover. But I was asking myself questions of how I would make a piece about World War II in an honest way. In the midst of all the images we had as children, and all the media, and the books, how do you find your own way to make a poetic piece? Obviously, I am not a playwright. I thought it would be interesting to have as the main character a child who was seeing it from far away. It would have to be an American child. I was very inspired by the La MaMa Annex. It was a great space. One hundred feet long and fifty feet wide. They had wooden bleachers, but they were more like platforms, and the space was only fifty feet wide so you were quite close to the performers. At the same time, since it was such a gigantic space with very high ceilings, I could create both epic and close-up scale.

Thinking cinematically, I could have my long shots and my close-ups. I could have my tactile sense of being close to performers and I could have my overall, epic view. At the time, with *Vessel*, I was very much a site-specific person. In that piece

the three parts were perceived from different vantage points. Part One was in my loft on Great Jones Street, which was a long, narrow space. I had the audience on one end and my living room was on the other end. It was like they were looking down a tunnel to the performers. Then, in Part Two, the audience was sitting on the floor of the Performing Garage looking up at the scaffolding. Part Three, they were on one long end of a parking lot, in a public space, looking from a distance.

With Quarry, *you are looking down into the space, and pools of light in the five different spaces.*

What inspired me with the Annex was that the audience was on two sides. They were sitting on wooden scaffolding. I was very inspired by photos of Nazi meeting halls, and the masses of people. The audience in *Quarry* became a backdrop. It gave a sense of a public meeting hall. The fact that they were looking down became almost like an airplane point of view. I became very interested in the idea of mandala, which is a pattern form. In the classic Buddhist or Tibetan mandalas, usually you will have a central figure, like the Buddha. Then, at the four corners, different aspects of his life. Or you might have six sides, where you'll have different images of his life, but you will always have a central figure.

The child became this central figure, almost as the observer. Then I had the idea for her to be a sick child, and that this sickness would be a metaphor for the world. The sickness would be her delirium and her internal world would reflect the fact that the world was getting darker and darker. In this space you saw

a pallet on the floor with a quilt, which was also a mandala—a mandala in a mandala—and there was the child lying on the floor, and then you saw the four corners of the world. They were delineated by light, with darkness between them.

There were some sections in *Quarry* where the whole space was lit overall. But the beginning of the piece had to do with the idea of realities going on simultaneously, the way that when I was on a train going out of New York I used to always be fascinated by the open windows of the apartments we passed where you could see people's lives unfolding. In *Quarry* each corner delineated a particular visual approach. There was a corner with two older people, and the color scheme was dark velvets, like maroon, burgundy, a dark green. You got a feeling that they were European. Later you realized that they are intellectual European Jews. They have a carpet that marked their corner. There was another corner where the floor was blue linoleum. There was a card table and three young women dressed in khakis and pastels, Rosie the Riveter-types. In the third corner, next to them, there was an Old Testament Jewish couple in black and tan biblical costumes. He was writing on a scroll; she was sifting grain in a basket. They represented the ancient roots. In the fourth corner there was a woman, who was an actress, in her boudoir with a bright yellow make-up table, wearing a very colorful, 1940s-style dress with poppies. So that was the mandala. It was very painterly. There was a color palette and texture palette for each corner. That was very much the way I was working at the time.

In addition to the structure of four corners in Quarry, *there is another spatial form you use here and elsewhere—the procession.*

I love procession.

Why is that?

Sometimes I go back to the ancient spectacle forms for inspiration. A procession is something that is archetypal, an archetypal form of community, of presentation. In *Songs of Ascension*, there is also a big procession in the end of it, and when we do a celebration service, which is a worship service, we circumambulate outside. We bring the whole audience outside. After I made a celebration service I saw a wonderful example of this in a church in New Mexico when I went to a service for San Miguel. In the middle of the service, there was someone playing guitar, and everyone got up and walked outside around the church singing and then they went back in and continued the service. I thought it was great. It was physicalizing the spirit. The procession form is beautiful because it has a sense of line.

Sometimes you have circles. For example, in Recent Ruins, *the performers are all singing in a circle lined by rocks. Or sometimes there will be diagonals or rectangles with the performers around the periphery. It seems there is always a special poetics of space.*

I love this idea that we don't have much in our culture now, How do you make a performance that conveys sacred space? If you are in Bali, you may be in a backyard, but it is very clear that once the performers go into a particular performance space—it might just be a straw mat on the floor of a garage—you are in a sacred space. There is a difference between one and the other. A piece I used that very consciously in was *Volcano Songs*. In the middle of the space I had a large piece of red fabric lined in black. There were two other zones, but the main zone was this red area. You could see that when I went onto that black periphery I was transforming my level of consciousness to enter onto the red area. I love that you saw that in front of your eyes.

I want to say one other thing about the way I have thought of myself as a visual artist. I still, to this day, use this way of thinking about things. What I like about visual artists is that they have a set of ideas, and then they make their first painting or sculpture, but maybe they hadn't realized all those ideas. So they go on to the next in that series. They could do ten paintings based on one set of ideas. Over the years, I worked with that. I always allowed myself to think of my forms as bottles, but my process as a liquid. If there was something from the bottle before that I hadn't totally realized, I allowed myself to put that into the next bottle. Maybe I would develop it a little bit more. Over the years I had a number of pieces that were series: *The Blueprint Series*, *The Plateau Series*, and *The Travelogue Series*. That is very much the way painters work.

Sometimes I feel like material needs to find its home. You can try it in different ways and it finally does find its home. But maybe it doesn't for a while. Some people work with their

bottles first, and then they fill them up. Certain people make their structure first, which I respect very much. It is much easier when you make your bottle first—I make my liquid first. That's my language or my process. And then, little by little, it finds its bottle. Sometimes it is easier to make the structure first. The other way is that you have to wait to see what that liquid wants to do. That is a little bit more organic. It isn't so neat and clean. Especially as I get older, I try to trust this way.

We keep returning to the subject of visual arts. Let's talk about your use of the floor. Can we think of that in terms of figure and ground? And when you are talking about the closeness of the audience to different performers, we can also think of your use of portraiture and landscape.

I have always loved the floor as the major element of looking at work. It is more like a painting, or a map. One piece I did, in 1966, called *Portable*, right before *16 Millimeter Earrings*, was my first use of the floor in a conscious way. My friend William Meyer, who was a sculptor, built me a white house structure on wheels. I would be in the house and do some material. Phoebe Neville was also in the piece. She had masking tape and she would make a track on the floor. Then we would move the wagon to the next place and that track would be left and I would leave an object. By the time the piece was done, the whole floor would be a map of where we had been. It was the idea of residue. Then, in *16 Millimeter Earrings*, I really started thinking about the floor as a canvas. It is an overhead view of a structure. To this day, my ideal space is a space where you can

look down on my pieces. That is really the big visual aspect—
what is going on on the floor from an overhead view. You miss
out on something in the frame idea of most proscenium stages.
You miss the depth and the visual gestalt when you are looking
at a frame. My work is not that pictorial, in the sense of a frame
and a picture. It is more sculptural.

In Songs of Ascension, *performers lie on the floor with instru-
ments on top of them.*

With *Songs of Ascension*, I always said to the performers on the
floor, "Please have your feet up, as if you are standing." It is as
if you took the whole image and turned it on its back. It was
a way of changing dimension. One of the strategies I have had
as an artist over the years is trying to disrupt your expectations
of dimension. It is always trying to subvert what we think is
up and down or left and right. Part of the strategy of being
an artist is, How do you create an experience for people that
allows them to see and hear in a new way? It opens up the pos-
sibilities of perception, so that when you go back into your life
you might be more open to the moments of your life, and see
things you haven't been aware of before.

*Let's go back to the question of portraiture and landscape. Often
we are looking at figures on the ground and the whole floor is
used, with the performers in different pools of light. You can
think about this as the creation of a landscape. But then, in
many pieces, there is a great focus on close-up and portraiture.
How do you think about these things in performance?*

That's a very beautiful question. In *impermanence*, there is one section called *Totentanz* where we do things with our faces onstage, and I always thought it would have been better if we could have enlarged our faces. I was trying to capture the way we have so much emotion on our face and if you sped it up, you would see all these emotions happening. Because we were small on a stage you never got the frame thing. My original idea of using film, in *16 Millimeter Earrings*, was portraiture and scale. I used that a lot—a change of scale, with my face very large or my face as a mask on a dome, like a big face on a little body. This idea of pulling close was what made me begin to work in film. I wanted to get something that I couldn't onstage.

An interesting example of that was *Girlchild*, where I consciously thought of the solo as a portrait of one woman's life. How do you make a non-verbal theatrical portrait of one woman's life? Then, in the group piece, in the first scene that we called the "Table Scene," I thought of that as the scale of still life. I thought of it as Caravaggio. The light coming down is white with no yellow in it, and the costumes are all white. For the "Traveling" section or the "Tale," I was thinking a lot more of landscape. In one piece, I was able to do all three perspectives.

Are there any other pieces where you have those three perspectives, or is Girlchild *the most outstanding example of that?*

I think it is the most outstanding example of getting all three, but *Volcano Songs* also had some of that. I was a solo figure in it, but the way the space was set up was really like one painting. It was like seeing one figure in this landscape and the figure

goes from one part of the landscape to the other. You get the figure as a portrait, but then you get that in relationship to the landscape. I don't know if you remember the film in *Volcano Songs* when the faces dissolve from one face to another. That's the scale of portraiture. It is very hard to get that portrait scale on stage. I don't think I successfully figured it out in *impermanence*. We used some film, but I couldn't figure out how to get the size. I didn't want to use portraits in that section. In the beginning there are all those people who were from the Rosetta Life hospice in London and you saw their faces. I didn't want to break into that in the body of the piece. I never solved how to get that face section enlarged.

Has the more recent use of video helped to solve the problem of portraiture?

Something I am always thinking about is the relationship of live performance to film or video. Portraiture implies scale, so that is something I continue to play with. I worked with the visual artist Ann Hamilton on two pieces, *mercy* and *Songs of Ascension*, and decided to let go of making video so that she could have her freedom to make those images. When you do a collaboration you let go of some of your territory so a third thing is allowed to happen. That is one of the principles of collaboration. If you are holding onto your territory for dear life, you are never going to get to something new. Ann is the only artist I have collaborated with in this way. In *mercy* she was using live feed with tiny cameras embedded in my mouth, her hand, on Katie's dress. The immediacy of this was very powerful.

With *Songs of Ascension*, she came in a little late on the process. I had worked in her tower and brought my ensemble there to test what it would be like, visually and aurally. We did a beautiful piece that was just for the opening. It was wonderful to work in there. I had made a preliminary form for *Songs of Ascension* in Dartington with the Elysian String Quartet, so it was hard for me to let go of that form, because I was very happy with it. In a way, I never felt that the film had much to do with *Songs of Ascension*. It was much more Ann trying to find a solution to how we would take a three-dimensional thing that we do in the tower and get that experiential and visceral feeling into a stage piece. Neither Ann nor I love the stage very much as a presentational space.

You said earlier that both of you struggle with the idea of the stage. Can you elaborate?

I hate the frame thing. Maybe it has to do with my eyes. There are some pieces that belong on a stage with a frame, and you go for the formal aspect of it and don't fight it. For example, the *Travelogue Series* piece that I made with Ping Chong. That works well on the stage because it is very theatrical and pictorial, and the images are rich in a pictorial style.

ATLAS, *too.*

ATLAS was made for the stage. That was what I had to work with. The second part of *Juice* was made for the stage to accentuate the frame idea. But that Renaissance perspective and

approach to a visual experience—I think because of my eyes I am much more interested in a three-dimensional, tactile relationship to images than just having a retinal experience.

Explain that more in relationship to your strabismus condition.

I don't see depth in the usual way. I can see that there is distance. If I am sitting at this table and we're next to the kitchen and there are windows, I can see that the windows are far away. But if I had the two eyes working together, I would see it in a more sculptural way. You as a normal person actually see two images packed into one. You see the way space curves around. I see space almost in a medieval perspective. I see layers. Yet, maybe being an artist is one of my antidotes. My work is so spatial.

Does it make directing in the theatre difficult?

Not more or less than any other space. In *On Behalf of Nature*, which I am working on now, we made it in a theatre, and what I am using in that piece is extreme depth. There are sections where we are so little we look like ants. I am using that idea of scale in a very conscious way to play on what I think is something that can be very powerful. You get the ant view and the dinosaur view.

That reminds me of the film in Quarry, *in the sense of scale. How did you fit that film structurally into the live performance and the historical view that was presented in five different scenes and three movements. Where does the film fit in?*

Quarry was a very complex piece with many layers and aspects. I would say that, maybe in my lifetime, I was the most on fire in that piece. I was getting ideas coming from every pore for months and months and months. Ideas were tumbling out. I had already started working on it—and had already called it *Quarry*—by July of 1975. I liked the idea of digging up the past and I loved the idea that it had another meaning to it, as in hunter and quarry. That summer I was going up to be in residence in Goddard College in Northern Vermont. We had a workshop we were teaching for two weeks. I already had some of the music for *Quarry*, and I think I already had the mandala idea formed. I had three characters: the Child, the Dictator, and the Radio Singer.

Somebody at Goddard told me that there was a quarry up there. And I just free-associated—a lot of my process is intuitive—and I thought it would be interesting to make a film in the quarry. I asked my filmmaker friend David Geary to come up. I went up there, saw the quarry, and then I worked the way I would with any site-specific space. The scale was part of what I came up with in these visual configurations of working with the space as it was. We were on a cliff and there was a big lake or a pond and on the other side were piles of rocks. I basically just looked at the space and then started doing configurations of people crawling in and out of the rocks, but the people looked tiny. I had women in the water holding onto logs. That was inspired by seeing Murnau's film, *Sunrise*.

I started thinking about the film as the Dictator's propaganda film, in an abstract way. I knew there would be a dictator character and I thought that he was going to show this film to

see what is being done in his nation. You're going to see these people almost like slaves on the rocks. I had the film by the end of 1975. That fall we did our first European tour of *Education of the Girlchild*. We went to Paris where we did *Girlchild* at the Bouffes du Nord. When I was in Paris, I found out there was a Jewish Archive, and I spoke to a man there to ask if I could look at the photographic archive. I said I was from a Jewish background and he let me look. I came to this one file, and there were fifteen shots that looked exactly like my film, with little tiny figures carrying these boulders. They were Jews who were forced to work in a quarry carrying rocks. They could have been frames in the film. They were shot in the same scale.

Quarry was, in my lifetime, one of the most amazing processes. Maybe that was the reason I was on earth this time around. I think I've made some other good pieces since that time, but that was the mid-point of my life and the mid-point of my art. It was as if Buddha was saying I must do this piece. That piece needed to exist. The urgency of a piece wanting to come to life is something that keeps me going. I try not to make a piece that doesn't need to exist.

Maybe it was also time, historically, to look back at WWII. You've done a number of pieces that have to do with historical time, cosmic time or geologic time, but this one had very specific political references.

I was feeling that there was a darkening happening at that time. These phenomena go in cycles. It is something that is a myth to our generation. It is still part of our DNA. A cataclysmic event

where the entire world was in conflict. What was that cosmically? I was feeling that those elements were coming back in—that neo-Fascist element and aspect. I felt that, if you don't take these phenomena into your body, it will just happen again. For example, Ping does not play the Dictator as Adolph Hitler. Its source and inspiration is WWII, but it is not only a WWII piece. It is abstract on a certain level. It definitely has those historic elements of that period, but I try to keep opening it out. You have five different dictator characters and a central dictator character who was a composite of Reverend Moon, Hitler, Mao Zedong. We were very aware of trying not to be too specific.

It is noticeable that more of the emotion and gesture is carried in the body, whereas in later pieces focus has shifted to the voice.

Quarry has a musical structure from beginning to end. That is why I called it an opera. And then it's a visual structure because of the three movements, Lullaby, March, and Requiem—that was a breakthrough when I had that idea. I always thought of those large pieces as an overall composition, and that gesture could be like a musical instrument. Gesture was a motif. I used all the elements as if I were orchestrating. In *Quarry* there are movement motifs that come back in a musical form, like the bicycle bells. They become musical themes but transformed into another medium, like gesture. Something I have found interesting about the world of objects you wanted to know about is that, for example, in *Vessel*, I used objects almost as if they were syntax. I used them almost as if they were phonemes.

The objects were musical notes, so they were used out of context. They were used abstractly as visual motifs rather than as functional. I also used them in scale. Rake was one theme. In Part One, a garden hand rake was used as a weapon in a fight two soldiers have. In Part Two, one rake was used as a King's scepter. Their function shifted. In Part Three, they were used as weapons for one of the armies. It was like taking something out of context and changing the scale of it.

Re-functioning it.

In those three-part pieces, I am always working with scale, and re-functioning it so it became an abstract, visual element.

It's like a musico-sculptural idea.

Musico-sculptural displacement.

A transformation from one medium to another.

Exactly! I am not so sure if I am inspired by that now, but a lot of my early work, as you were saying, was taking something from one medium, transposing it to another medium, and shifting it, as in my first piece in New York, *Break*. I was very inspired by cinematic syntax so I made a solo piece of cuts and dissolves in a live performance piece. The idea of taking some syntactical system from one medium and transforming it into another medium—I was very inspired by that.

That is true Intermedia, rather than multimedia.

I was never a multimedia artist.

*I think there has been a confusion of terms around media.
Your way of working seems to me to be a classic example of
Intermedia, because it is a juxtaposition of elements and forms
that don't necessarily belong to one another but create a new
kind of poetry. That was Dick Higgins's vision of Intermedia. It
encompassed poetry and anthropology and collage—all kinds of
intellectual forms and subjects. It is such a nuanced idea. You
are working in film, in music, in visual art, and in theatre,
transposing one media to another and re-functioning forms and
objects.*

And weaving or integrating strands of ideas to make a new,
integrative form. In those days, a lot of people were doing
mixed media or multimedia. They were very influenced by
Marshall McLuhan and "the medium is the message." They
would throw on all these tapes that didn't have anything to
do with anything. More was more. But I was never interested
in that. I was interested in how you take these things, and by
weaving them into a rigorous and, you could say, necessary or
essentialized poetic form, get to something new.

This is what I have written about as "mediaturgy."

That's great.

It is different than dramaturgy in that there is more embed-
dedness of text and image, which is part of the dialectic in your
work. Many of your works use very minimal text. I wonder,
how have your thoughts about language in the theatre evolved
over the decades?

Sometimes something needs text, but I have always thought
that my singing, or some pieces of it, are right at the line
between text and non-text. Even if the singing is abstract,
sometimes it has a conversational quality.

Between speech and music.

In my work there is a tiny line between speech and pure pho-
nemes. You do get the feeling of a voice speaking, even if it is in
an abstract language. In a piece like *impermanence*, which was
dealing with something ephemeral and ineffable, I realized that
I had to ground it somehow. I decided to include some words
that were more like lists or litanies. I felt that *impermanence*
needed the concrete quality and solidity of words to keep the
piece from flying away. The fact that I use words abstractly is
still a musical idea of text as opposed to a narrative idea.

In impermanence *the performers have such individualistic*
turns in what they do. I love the last scene, where there is a train
in the distance and someone comes in on skates. You are talking
about the piece flying away and there is a sense of floating. I
want to talk about your use of light in the piece. The cyclorama
turns various colors, creating a beautiful use of light.

Noele Stollmack did an unbelievable job. Yoshi and I, when we were working on the costumes, talked a lot about color. I work visually. I started working with Gabriel Berry on Act One, and Yoshi came in the middle of it. The idea was neutral colors, and that each person represented a different type from the earth. Katie was in her evening gown, I was in my jeans, and Ellen was in her little dress. It was like representatives of the planet in black and white or neutrals. I was trying to figure out what we were going to do in Act Two, and Yoshi said, "What if we make the exact same costumes but in one color." We decided on violet, almost like ultraviolet light, as if the individuality of each of these characters became like a soul. Almost ghosts of those characters. I was wearing a white 1940s shirt and jeans, and he made the exact clothes in violet ultra-suede. As if all the individuality and color went out and you just had the essence of the person. We all became the same because we were in the same color. But we still had the same shapes and individuation.

It was very much the idea that I really noticed when Mieke died, all the things we think of ourselves that we talk about in "Liminal." We say, "she called tofu 'pillows.'" "He always touched the wall before he left the house." We have idiosyncratic habits that we think we are. When someone dies, all of that goes. What really stays in your mind is the love that that person had and the essential person. The whole piece was like that. When we were in those purple clothes, our essential beings stayed. The content was differentiated by a visual idea. In *impermanence*, it was very important that it was only street clothes. But with On *Behalf of Nature*, because Yoshi is making a composite from street clothes, you could call them costumes but you could sort of call them sculptures.

Earlier I mentioned the variation of color in impermanence, *ending in yellow, but you often use blue light. I am thinking of* The Politics of Quiet.

There are many different lights in *The Politics of Quiet*. There is a golden light and a beautiful Par 65 light, that is the white white white light. The scene where they are all in the black coats I use in *Quarry* for the rally. It has a slightly purple quality to the light, because there is no yellow to that color temperature. It is bright and like flood lights. It is such an unusual color. If you are wearing gray it turns everything a little purple. The *Girlchild* solo is in blues. It creates a dream-like world. In *Quarry*, during the dream with the child sitting and Lee Nagrin slamming the spoon on the floor—that is the girl's dream or her nightmare—that is in blues. We use color in a very conscious and pure way.

There is a lot of darkness in the pieces, too. Light and darkness.

I think of light as a concrete element that is a counterpoint to the work. Working with Noele on *impermanence*, I said, "Noele, your lighting is like another instrument. The lighting should have its own integrity. It's not like you're lighting just to show us. You're having the light have its own reality and its own rhythm." If you remember "Liminal," I said that I want light coming from different angles, so if you looked at Ellen Fisher and Ching Gonzalez sitting on the chairs, you were seeing it from overhead, and then from one side, and then from another side, and then from underneath. Noele does very sharp

changes from one angle to another so that the piece is very lyrical but the sharp changes of perspective are like staccato impulses against that more lyrical continuity. Light is something in itself.

> *It is another language. We have also been talking about objects. I've been fascinated by the use of utensils in your work and the drawing and projection of objects. In* Recent Ruins, *a spoon is drawn during the performance. In* Girlchild, *you are carrying a house on top of your head and someone is carrying a globe. Objects also have a sculptural language to them, like the clothing you mentioned earlier. They are not just props.*

Absolutely not. Props are something that assists the performer. They're decorative. That is why one of my early questions in each piece is, Are we going to have objects? For example, in *On Behalf of Nature*, we felt like we did not want objects because objects are a world in themselves. Yoshi and I talked about it with *On Behalf of Nature*, that somehow objects were too hard. Too concrete. We were going with more of a process. Time, nature, growth. Objects are too what they are. The same thing happened with *impermanence*. The only objects were two chairs. I wonder if I will go back to working with objects again. I loved that. I miss it. But so far, objects are too concrete for these pieces.

> *Do you feel that as you are moving more towards musical composition, and having music take over, you are using fewer objects? Whereas when your work was more theatrical, you had more use of objects?*

Probably. It would be interesting to go back to objects and see what that would be in terms of the kinds of forms that I am working on now. But again, I would use objects in a very abstract way.

Even when you are not using physical objects, there are objects that have been in a lot of the recent videos. In The Politics of Quiet *there is a film with images of a toy train, children playing, a Slinky. The poetry of ordinary objects is what interests me in the work. Maybe, when the work was more theatrical, there was more of a need for objects.*

Did you like the section in *The Politics of Quiet* when we preserve ordinary objects in beeswax? It is like a ritual. The performers bring an ordinary object out, they dip it in a vat of beeswax, and then it hardens and we put it on a shrine. I actually made an installation at the Walker Arts Center with those objects. We made a big octagonal structure painted red with steps that went all the way up. And then in workshops, when my exhibit was there, they had workshops having kids bring in objects and dip them in the wax, and they learned about beeswax. Then they added them to the shrine. The whole thing, by the end of the summer, was piled up with these ordinary objects covered in wax. TV sets and everything.

In your piece you use a saw, and someone is carrying a hammer, or a tennis racket. It's acknowledging the ordinariness of objects.

I was thinking about memory. I am always thinking about the earth as if it were going to end. There is always this elegiac idea.

Apocalyptic?

I had my apocalyptic period, which was *Recent Ruins, Turtle Dreams Cabaret, The Games,* and *Specimen Days.* Then I realized I didn't know how useful that was. I felt like I was stating the problem. I decided that a more useful art would be offering an alternative. But, that is not to say that one little layer of consciousness is not always in there. I just think that there are ways of getting to a deeper feeling tone than hitting the nail on the head or laying the cards on the table in a particular way. Maybe that is more a literary form.

> *What's very identified with your work is the quest, or journey, especially since you often use the girl archetype. I am thinking of* ATLAS *or* Quarry *or* Book of Days. *It seems that the focus is more the search and the questioning, rather than having an answer.*

It was always like that. Absolutely.

> *Besides the young girl there are many themes regarding women and the stages of women's lives in your work. In addition to the pieces I already mentioned, there is, of course,* Education of the Girlchild, *and the young woman with the moustache in* Paris/Chacon. *How do you view women and gender roles in the pieces?*

I feel that it probably came from trying to understand human nature, the male and female in all of us. I always felt to be a

full artist you have to understand both sides of yourself. As a female artist I would want to understand my female nature and my male nature. In *Paris* there was a kind of love duet with Ping Chong, and we were very much trying to go to the edge of male and female nature. We were a composite of male and female. I had a long skirt and my hair was in a braid but I wore a moustache and a leather cap and big combat boots. Ping had long hair and a shirt with puffy sleeves. We were playing with what a composite male and female would be, not doing drag. In *Chacon* the farmers were in suits, male and female. It was just exploring. It went to its ultimate in *Specimen Days*, a piece about the Civil War where I played Louis Gottschalk and I was in tails, and Gail Turner played Matthew Brady. We had one section where people were waltzing and Paul Langland was in a hoop skirt. We were exploring dualistic mind. Male/female, black/white, north/south. I was going all the way to analyze this dualistic mind because I think all wars are created from it.

When I did *Paris* I was thinking a lot about silent comedy. I looked like Charlie Chaplin because I had the moustache but my style was much more like Buster Keaton. It was deadpan, humorous movement. What I found wearing the moustache was that it gave me freedom to do stuff I don't think I would have done without the moustache. I don't know why. I loved that character. It reminded me of my grandfather, who was a dandy.

Would it interest you to return to that? Or was that more of its era in the seventies?

Not particularly. At that time, I was exploring my sexual iden-
tity as well, and how wide the parameters could be. I was never
a part of the women's movement. I wasn't political in that way.
But I was so relieved when the women's movement came along
because some of the things I had suffered from in my twenties
made me see I was not alone in that suffering. When that came
in I realized that what I thought was my private suffering was
actually a public, political problem. Certainly I was thinking of
those terms in the early seventies when I chose the title *Educa-
tion of the Girlchild*. Coco Pekelis wore a moustache in it. The
main characters were six women. The question was, What if
you took half of the human race out and left the other half, and
they became the whole world? I remember Lanny and Lee and
I were talking about going back to the archetype of matriarchal
society where the women had to do everything.

> *Did you feel at the time that your struggle was as a woman to
> be an artist or simply just to be an artist? Were their pressures
> in the downtown scene or was it already opened up by perfor-
> mance and dance?*

There were wonderful older female artists—Carolee Schnee-
mann, Yvonne Rainer, Elaine Summers, Sally Gross, Alison
Knowles. I was a determined young women. I was driven. My
problem was not in being an artist. I didn't realize how much
my being a woman would get in the way of being an artist in
the art world. I wasn't aware of it. I was just doing my thing.
My pain came from being treated like I was a bad woman, in
my personal life. That being driven and assertive and doing

my vision was really bad because I was not a supporter and a nurturer of men. The men were the ones who made me feel bad. It could just be that they were not strong men. It was very painful and the way that I took it was as if there was something the matter with me. Yet, there was no way I was not going to pursue my vision. It was not negotiable.

How long did that period last? By the end of the seventies women were so prominent in Judson dance, video, performance art, which is not to say they were any more accepted in museums and institutions.

I think it shifted in the late sixties and early seventies.

Is it an issue any longer?

Sometimes it is in ways that are so mysterious. But it is never an issue in my thinking. Sometimes crazy things happen, and I realize, "Wow—is that operating in the world?" That's shocking; it makes me sad. I realize there were some men who underestimated my power as an artist. It made me laugh on one level, and another, it was—"You have no idea who you're dealing with." You can hear in my voice it makes me angry. I certainly have some feelings about it but it isn't part of my daily consciousness, because long ago I made a choice about what was important in my life. In the long run, in terms of being on the planet and then leaving it, that doesn't matter at all.

You've lasted forty-five years.

Fifty!

In a way you've had the last laugh.

I guess.

One thing we haven't talked about enough is the humor in your work. You are such a humorous person. I am thinking of the playfulness, the joy, and sense of the community the performers exhibit. They do so many funny things—peculiar gestures, making faces.

I have always loved humor and maybe because of my size I have always been good at comedy. Comedy is one of the hardest things to do timing-wise, it's a real discipline. I always felt that I never wanted to do a piece that didn't have humor in it, even if it is a very serious or sad piece. The artists I have loved best also know this. In Rossellini's *Rome Open City* here is this grim film about WWII and the occupation of Rome, and in the middle of it is a hilarious scene where you are laughing, and then you are back to the seriousness of the situation. It is so important, and, also Shakespearean. In *Quarry* there is a lot of sadness but there are humorous parts with the little girl dancing around with the maid, and the buffoon dictators. Just to break that tragedy.

I have always felt that we don't have to call something comedy or tragedy. Why can't we have a spectrum of emotions within one piece? The whole palette of emotion is wonderful to have. In comedy you can have a lot of poignancy, and that

to me is the best comedy. I always try to make it so there is something that breaks the somberness. In *impermanence* it was so nice to break the mood in the midst of much more subdued, sensitive, and delicate material with the spontaneous and playful "Particular Dance."

Do you think your love of old television comedy and silent film has been an influence?

Oh yes. My mother was so funny. She was a real clown. We laughed a lot in my family. I just think I have that in my nature. The playful thing you brought up is something that is very important. When I am having trouble working, even with *On Behalf of Nature*, feeling stuck—it was hard—I keep on saying to myself, "Remember beginner's mind, Meredith?" I think the playful quality that we have in rehearsal and that we retain in performance is something that gives the work more depth. When you are playful you are open and things can come in. What I love about Suzuki Roshi, a Zen master who came from Japan to America in the late fifties, is the way he talks about beginner's mind: that everything is a possibility. If it is "expert's mind" you already think you know what it is so you limit possibilities. But "beginner's mind" allows for everything to come in.

That's why so many artists value the sense of retaining something of the child, like the strangeness that children have where they'll just make a gesture or say something that we filter out as adults.

Sometimes people think that it is childish, but it's not, it is child-like. People get confused. One of the things we are trying to do as artists—it's not romantic—is to get to a point where we are seeing things in a fresh way, in a way that we've never seen them before, the way children do. So we are acknowledging the magic in every moment that we have.

And it's not a form of nostalgia but the history of an entire human being.

Exactly. Rather than nostalgia it is teaching us how to be present.

Speaking of which, the musicians are present in a unique way in your work. They come into the performing space now more than usual, and sometimes interact with the performers. That leads me to think not only about the sense of play but also about your view of labor, because of the way you are recognizing their labor.

Since *Magic Frequencies* I have been working with almost the same people. It is really exciting for me to take the same group instead of recasting every piece and exploring something else with them. Another question I ask when I am first working on a piece is, What is the relationship between instrumentalists and singer/mover/actors? Each piece is different. For *mercy*, the instrumentalists really were the instrumentalists. I think they pretty much stayed in their area. In *impermanence*, I was thinking that Theo Bleckmann and I both play keyboard. Why

shouldn't Theo and I play sometimes? We have a pretty talented group of people who have all kinds of different talents. Why shouldn't Allison get up off the piano and come sing with us? There is an area for the instrumentalists but also there are times where we go and augment them instrumentally. Allison, John, and Bohdan [Hilash] at one point join us in the end for a line where we all sing.

I love that it was permeable. It was like a skin that could go both ways. In *Songs of Ascension*, there was a string quartet and the instrumentalists, and I had the string quartet walking around and lying down. We didn't go and play with them, although Allison did pick up her fiddle and play a few times. But mostly they were instrumentalists and we were singer/performers. I had them walking around and lying down. With *On Behalf of Nature*, we have the instrumentalists dancing and singing with us in some sections. This time we don't play instruments. But Allison comes and sings with us. There are parts where everyone performs large landscape patterns where it is almost like seeing a field at night. The instrumentalists sing and move with us. They're not schooled movers, but what I think it says, and what I love about it, is that it becomes a "Wash," and you get to see the whole community with no differentiation and no hierarchy. It also makes a different texture. I call those "Wash" sections. They are large landscapes and then we go back to our places and do things that have a little more particularity.

That really is a different way to think of collaboration.

I love that there is no hierarchy, even though it is challenging for them. Musicians are not trained to work in space like that.

That's why I asked you to talk about your attitude toward labor.

I think we are pretty equal in terms of our energies. They are such extraordinary instrumentalists so when we are singing and they are playing—even when we are in two different places— what they are putting in there is at such a high level, why shouldn't there be points when we are all equal? I keep learning more and more about the instruments. There is always this learning between people and filling in where you don't have the training. It also makes it really exciting for the instrumentalists. I think they love it.

How do the performers feel about it?

In *On Behalf of Nature*, Ellen Fisher and I are the two most experienced movers. We keep on working to get the others up to speed. It's the same philosophy—every piece is a philosophy. I think my work all these years is about philosophical statement. It never has been me making artwork, and then we cast people, and then it's showbiz. That is why it is very hard to convey this work to other people. I can't have a pickup company. It is not just learning the music and the songs. There is so much more. That is what is difficult even with the younger performers who are learning my work. They learn the music but it is very hard to understand everything that goes on around it, because they came up in a different generation.

In terms of moving, since movement is highly individualistic, how much does each performer bring to the creation of his or her performance?

Sometimes there is a movement theme I like everybody to have. But of course they can interpret it in their own way. In some ways I am more rigorous in music than I am in movement.

Do you demonstrate for them?

Yes. Sometimes it is my vocabulary. But I hold on less to my authorship of movement than I do of the music. The music has to be a certain way, and that's it. I try to make the voices sound different. I make the music for the particular voices. But those forms are locked tight. In movement what I like to do is let people explore vocabulary because then I get a chance to learn about their bodies. But I shape that vocabulary. You see that a lot in *On Behalf of Nature*. I really work hard on it. In the beginning when we are in line—I've refined that in ten different ways and I finally got to a much more totemic look to the movement. I really work with principles they can fulfill, and then I say yes or no.

After all these decades, what have you learned about the performing body? What kind of performance knowledge has it given you?

I have always been very interested in having a performance style in which you are one with your material. We do not do

a real presentational "This is me and I want applause" kind of style. It never was that. In a way you lose yourself in the material. It is a quiet performance style. I feel like I have always been like that. I do think that a performance, short of meditation, is one of the times in life when one has the potential of being completely awake to the moment. It is very pure. Your brain is not going a mile a minute or commenting on yourself or anything. I have not been that interested in getting immediate gratification, although I do like this idea that the audience's energy is incorporated into our work. But I don't need it. It isn't a needy thing. We are in the center on our axis and we allow the audience to have their axis. We are in the same place at the same time, exchanging energy. Like an infinity sign. But we are not dependent on them loving us.

We are trying to create an experience in which the audience can be immersed. They can go as deeply into the experience as we do. And we are also very vulnerable. Live performance is one of the only places now where we can have that sense of vulnerability in a public place. When you see the vulnerability and the generosity of people on stage, it helps you to open your own heart to the rawness of existence as an audience member. Maybe it opens up your emotional palette in a way that you don't usually have to. It allows you to have the raw heart.

It also relates to something you said earlier, about how you are not interested in the audience "just looking," but rather in experiencing. That is something that could be very philosophically profound in terms of the affective nature of art practice and the audience relation to it.

I feel that art practice is spiritual practice. Art practice means that you want to consider what your art practice is doing in terms of the world. Are you doing something of benefit or just for yourself? Many young people have to do work for themselves, but you get to a point when you are wondering what you are doing on the planet and what you are leaving behind, and is your practice something of benefit to sentient beings? It doesn't have to be direct. It doesn't have to be political—it doesn't have to be about telling people to get rid of their plastic bags and recycle. That is something that was giving me so much trouble while working on *On Behalf of Nature*. How do you do a piece called *On Behalf of Nature* and what is it, exactly? Am I supposed to be telling people to call up the guys to not have fracking? I remember someone told me while I was having trouble that I should work with my experience with fracking. I said I don't work with my own problems in my material.

Today, people are focused on the journalistic approach.

I feel like that is being done over and over again, whereas my approach is musical. Music is as natural as breathing. You can make a piece about the soul and about breathing in this world, realizing that everything we are looking at every moment has the possibility of disappearing. To me, that is a much deeper statement. I wish I could do something that was more direct about telling people what to do. But I think that the truth of my work, because it is so abstract and musical, is that all I can do is this.

What is the arc of where you started and what you have learned over time?

In terms of creativity, something I am learning even today is, when you are younger, in a way you have more ideas. You've got more concepts. *Quarry* had millions of ideas in it. But I can no longer work that way. I remember John Cage saying that one can have too many ideas and that ideas get in the way. In my Buddhist practice we try to get past conceptual mind, which is something that takes you away from experience. If I take that idea and have the courage to put it into my creative process, which is scary, I have to just allow the material to come up. I have to trust the material enough, not judge it too early, but just keep working with it. Delving into the material and then allowing it to make itself known and to make the structure, and literally not being harsh but following the purity of the material. When you see the piece you actually see that that process is in there. There is a sense of trust in how simple you can get. I am always skeptical, and that demon talk comes up for me. But then I realize at a certain point that this is my material, and I am going to let that material take me where it will lead me. That is a real learning curve. I would not have understood that as a young artist. I would have been very distrustful of that. I wouldn't have had the patience.

Aren't you are describing the process of the working artist over a lifetime?

You essentialize as you get older. I think you start discarding and leaving in there only what is necessary. That is part of the

process of getting older as an artist. It takes a lot of work to do that. It takes many, many hours and many, many days and many, many weeks and many years to shed. As a musician, I am going in the other direction because I am allowing myself to keep refining my craft, and I keep learning more about instruments and become more daring in musical terms, really exploring things like bi-tonality, dissonance. Exploring areas of harmony I would never have thought of before. The colors of instruments have been very exciting for me to learn.

> *Recently you worked with the St. Louis Symphony. It seems as if your composition is also moving towards chamber music and symphonic music. The complexity and the arrangements are changing in your later work.*

I am loving that, but I know I wouldn't only do that. I need to go home to my family, and my ensemble is my family. I give them a kind of freedom that I could never give to an orchestra. An orchestra needs to have every last note written out. John Hollenbeck can come in, even though I have most of the music written, and what he adds in terms of percussion is always brilliant. He knows my music. He knows my vocabulary. He knows my syntax. It always is exactly right for what I am doing. I could never do that with an orchestra I am just meeting for two rehearsals. I love that I am exploring these larger forms, but I would never give up what I am doing with my own group for that. Writing for an orchestra is many steps away from me, whereas with my group it is still part of my body.

What is at stake in all the transformations and creative processes that you've been working with over the decades?

I am trying to keep it new and fresh and risky. If you don't do that, you just get tired and bored. And it's horrible to be risky! I think, Why am I doing this to myself?—one more piece where I start from scratch. Why don't I just do a piece with things I already know? But why would I do that? My way has always been about process and learning. If I never learned anything else at Sarah Lawrence, it was that learning is a great thing. You want to learn your whole life. I love that, as painful and tortuous as it is. It is the thing that keeps me going.

(JULY 7, 2013)

Quarry: An Opera in Three Movements, 1976. Photo: Johan Elbers.

V

In 2019, the restored film of your great piece Quarry *from 1976 was shown in New York City, and the 1991 opera* ATLAS *was directed by Yuval Sharon for the Los Angeles Philharmonic, the first time anyone else has staged one of your theatre works. How does the work look to you over time?*

I think that the essence of the pieces still holds true. I'm the kind of artist who is interested in cycles of time and in a more timeless way of thinking about art. It seems to me that there are two basic categories of the way that artists work. There are people who are a direct reflection of the time they live in, and their work does have a sense of that period. Then there are other people who are more interested in recurrence. It's not like there is no relationship to what is going on in the present but instead it is trying to dig below that to the things that are more cyclical throughout time. And that's the way that I think I am, or I try to be.

You have worked a number of years on restoring the film of the Quarry *performance. So many of the themes are relevant today, such as the issues of fascism, antisemitism, childhood trauma. What were your thoughts seeing it again?*

I was very surprised that a person in her early thirties would take on the scope of something like that. Though I do remember

the process very well, I see that I was trying to deal with something that was very overwhelming in terms of scale and depth. One of my questions to myself as I was working on it was, How does one do that? I began to think of *Quarry* as a poetic documentary dealing with something that is historical but, I hope, in a fresh way. We have so much information about World War II from media and writings from the period. Knowing that, How does one make an artwork that is honest and adds personal insight to what we know? The personal, to me, sometimes can become the most universal. Now, looking at the film I see a few things that I would change. I think that it's always like that when you get to look at your work after many years. We brought *Quarry* back a few times over the years—in 1985 at La MaMa, in 1986 at the Kennedy Center, and in 2003 at the Spoleto Festival, Charleston—and I did make a few little changes.

What were the kinds of changes that you made?

The main character in *Quarry* is an American child who is sick. Her illness becomes a metaphor for the world descending into darkness. For most of the piece, she is lying on a bed/pallet on the floor in the middle of the space. In a sense the whole piece is about awareness, the power of memory, and how external events are imprinted in our consciousness. I originally called the piece *Quarry: An Opera in Three Movements*. After the first two movements, Lullaby and March, there is a section that I called "Cloud Dance," in which performers carrying huge sculptures of clouds on long sticks move slowly around the

space. I always thought of this section as a purifying of the space after the violence of the March movement. After that, the child who has left returns, but now with a coat over her pajamas. She runs urgently around and around her bed. She stops suddenly and bends down, then slowly rises and looks up. There is a sense that she wakes up out of a dream and that she will go on to the future with strength. Then she begins to walk around the bed singing the music for the last movement, Requiem, and is joined by the whole cast. That section always stumped me. How to bend down, how to rise, how to make the transition into the Requiem? So, each time we revived *Quarry*, I tried something else. In one version, I tried a duck-and-cover gesture as I went down.

That came from a strong memory that has stayed with me even though it was from a different war, the Korean War. When I was eight, the teachers at school told us about the atom bomb and had us go down to the basement of the school to learn duck-and-cover drills. I had never heard of the atom bomb before, and I remember being so horrified that I wanted time to rewind to before knowing that such a thing could exist. At eight years old, I already had that awareness. It was like eating the apple in the Garden of Eden. I sensed that my life would never be the same because I had that information.

It is so suggestive to think about the memory bank, the image bank of childhood, and the significance of that for artists. There's a little girl at the center of Quarry, *and in* ATLAS *a young girl is in the opening scene.*

That one was very different because the scene was much more about the longing that we have, particularly as young women, to fulfill ourselves and be whole. That scene was about something that I work with a lot in my pieces. It's what happens, especially for young women, when you actually have a vision of something and, in a sense, when you receive the call to follow a path that may not be something your parents want you to do, or even that your culture wants you to do.

> *The opera itself is such a large cast piece and has more narrative than your recent abstract work. Are you interested in doing that kind of big work anymore? Do you look back and think, How did I put that together?*

I don't think I am quite as interested in narrative now, but at that time I wanted to examine the opera form to see how I could incorporate its elements and figure out a way to weave them into a whole that would reflect more how our minds work, not to create a straight narrative. While *ATLAS* contains shards of narrative, I still consider it a poetic form. From the time I was a very young artist, I wanted my forms to be non-linear. I'm working on a piece right now, *Indra's Net*, that is very abstract and environmental. Yet I'm feeling that I might need to include what I would call the "earth realm" in it, and at least have elements of individual narratives or some differentiation of character or persona, within something that is much wider and more spacious.

It sounds like you are working out the process while not know-ing what form it will take. But there definitely seems to be a sense of the work becoming more abstract and reduced to essen-tial elements.

Exactly. It's more abstract because the musical aspect of it is more complex. I always say that music is very demanding in and of itself, but in the Western tradition when you put images or movement to music—because we're a visually oriented cul-ture—the music then becomes accompaniment in the audi-ence's perception. Something that I had been working with in *On Behalf of Nature*, and now also with the new piece *Indra's Net* is, How do you create a situation that allows the audience to have the space to perceive the complexity of the music, and also includes movement or gestural elements, visual images, and human interactions?

I remember that with *On Behalf of Nature* I was very ner-vous about it because the movement material I was working with seemed so simple theatrically. Then I realized, no, it has to be that transparent so that you can actually hear the intricacy of the music. The music doesn't become the background to what you're seeing. I also worked with that principle in the more recent *Cellular Songs*. The gestures and movement were simple, austere, not exactly emblematic, but more iconic, and yet, very transparent so that all the elements could happen simultane-ously. The singing and gestures were very intertwined.

Do you still worry, as you have said in the past, that you don't
have more visual ideas? Is that a concern anymore or do you just
let the pieces evolve as they go?

I've learned from both *On Behalf of Nature* and *Cellular Songs*
to just let the ideas evolve as they want to. The visual aspect of
Cellular Songs turned out to be really beautiful. It might have
looked stark, very pure, but to me, that was its strength. I was
really paying attention to every detail and molding the visual
elements with my designers. The texture was less dense visually
than in pieces like *ATLAS* or *Quarry*, but, I hope, just as strik-
ing. I was working graphically rather than pictorially.

Can you elaborate on what you mean by contrasting the graphic
and the pictorial?

One reason *ATLAS* is more pictorial than a work like *Cellular*
Songs is that it was designed for a traditional proscenium stage.
As early as 1967, I began to work in different environments to
get away from the frame and frontal orientation of the prosce-
nium. I was much more interested in offering the audience an
immersive, tactile, visceral experience. I wanted the work to be
flexible, transparent, and responsive to different spaces. *ATLAS*
was commissioned by the Houston Grand Opera for their
opera-house stage. I tried to find ways of working within that
situation that maintained my more sculptural, multi-dimen-
sional approach, while honoring the theatrical parameters of
the stage. Looking back at videos of my original production,
I see that I was meticulously weaving elements together and
creating simultaneous perceptual codes.

I worked with Yoshio Yabara, my longtime costume and set designer and artistic soulmate, to create a production that was opulent but used simple means, leaving space for the audience's imagination. At that time, my impulse was to be more mono-chromatic, and in some ways more visually austere than Yoshi, who comes from a coloristic tradition. What we came up with was to use color as a narrative code or language. There was almost no text in *ATLAS*. Instead of relying on sung text, the narrative was conveyed by visual, gestural, and musical motifs that delineated character and situation and provided an under-lying layer of content. For example, we dressed the two charac-ters called Spirit Guides, who inspire the journey of Alexandra, the main character, in taxicab yellow and black throughout the opera, even though they had numerous costume changes. The last act, Invisible Light, takes place in their realm so we dressed all the performers in yellow and black. For the audience, that connection might have been subliminal, but it was there.

In terms of setting, since the piece was performed on a proscenium stage, we had to contend with how to make the environment visually rich but maintain our sensibility of not relying on the opera convention of monumental, complex stage technology. Beverly Emmons designed marvelous light-ing, which became the prominent scenic element, creating rich and varying landscapes. In a way, we were painting in light.

I remember the yellow in the wallpaper in the first scene.

In addition to the color language, I also worked with gesture as a dramatic code. A certain gesture referred to a particular

narrative event or situation. For example, Alexandra always performed the same gesture to indicate that she was accepting someone into her group of explorers throughout the opera, and there was a sequence of gestures the Spirit Guides performed that recurred. I don't think that audiences really noticed how it was working but it communicated subtly.

Yes, that's so nuanced and one would have to see it more than once.

It's very nuanced, but I do think it seeps into your unconscious mind. I've always worked like that, in one way or another.

What happens then if ATLAS *enters the repertoire for future stagings? You've given such a precise sense of how you staged the production. Can you conceive of letting go of your work more often?*

Well, this was a really interesting experience in Los Angeles because I was working with the opera world as it exists. My thinking was, let's see what would happen if I operated like an opera composer, just being in charge of getting the music to the highest quality that I could rather than creating all the elements. For the Los Angeles production, that meant I had to clean up the score, which took more than two years. The vocal parts of the score were just sketched in but all the orchestral parts had been completely written out for the original production because orchestral musicians usually can't participate in the kind of learning process that I demand of my singers. They only get a few rehearsals.

That is the classical music world's standard way of working, mostly because of financial restraints. In the original 1991 production, I had a whole month to make an ensemble out of singers who had not worked together before. Then I had a few months to rework material and rewrite it for those particular singers. Later we had another month rehearsal period, followed by some more time for me to rethink and rework, and then the usual six weeks before the performance. But orchestral musicians don't usually get that kind of time, because they are hired near the end. It was my choice to use a large part of my budget on rehearsals rather than elaborate production elements.

Most of the vocal parts were not written out. I worked the way I usually do, which is that I come in with material and I literally teach it in rehearsal. It's learned physically. In L.A. I had to pull all that together. It was really hard. When I work with my singers, they know where they can take a little liberty, where it has to be absolutely precise, and where there are places that they can play with the rhythms a little bit. Otherwise, it just gets very stiff. So, that now had to be codified in the score—that was my realm of work for the L.A. production.

But then you had to give it up to another director.

I was curious to see what it would be like. Part of what I am thinking now is, How will this work go on when I leave the planet? How do I pass this on? This was an experiment. What would it be like to have another director? The thing that was interesting was that I already knew Yuval Sharon, who is a really good friend. I knew him from singing the John Cage

Song Books with Jessye Norman and Joan La Barbara. He was the director. I had never been directed by anyone else before, so it was a fascinating experience. Yuval was wonderful with us singers.

The *Song Books* production was by the San Francisco Symphony and performed by Michael Tilson Thomas, members of the symphony, and us three, in 2012 and 2013. We performed it at Davies Symphony Hall, Carnegie Hall, the University of Michigan in Ann Arbor, and at the New World Symphony. It was an incredible adventure. I never knew what the piece ended up looking like because one of John's instructions was that the performers should not relate to each other but concentrate only on their own sequences of songs and actions. Yuval created a complicated time structure. The rigor of performing the piece was a challenging task but I also found it very refreshing. It brought back memories of some of the task-oriented performing that I did when I first came to New York. I knew that Yuval was a great person and a very creative artist. And he had said to me, "One of the goals of my life is to direct *ATLAS.*" So, that's how I went into it.

The early part of the process consisted of spending a few days talking with Yuval about the concepts of the piece. I went through it meticulously, scene by scene. At the end of those sessions, he said, "I would like you to approve of all my decisions." And I said, "I don't really think that's the way to go this time because this is an opportunity to see what it is like for someone to work on it independently." One thing that I did insist on participating in was the casting because that is really essential for *ATLAS.* I was looking for singers who were adept at and comfortable with

integrating singing with movement and acting, who had good rhythmic ability, a pure approach to tone, and an open attitude to using the voice in non-traditional ways. Since the theme of *ATLAS* was travel as a metaphor for spiritual quest and the universality of human experience, it was crucial to have a racially and ethnically diverse international cast. I was also looking for people with a generosity of spirit, luminescence, and humility.

Were you able to achieve that in Los Angeles?

Yes. We found a group of beautiful, talented performers. Half of the cast came from L.A. and half from New York. At a certain point, I realized that I needed to teach Yuval my process of auditioning, because he began by running auditions the way that opera auditions are usually run. Singers come in dressed in fancy clothes and sing their arias. Yuval had them move around a little but the space was somewhat confined. After each audition, he would send me a video. I said to him, "Yuval, I can't see much about these people with this way of auditioning." I usually audition thirty people at a time because then I can see how they work with each other. By having them sing canons, I can hear if they can part-sing, and then I have each of them sing their part solo so that I can hear their vocal qualities. By auditioning with this approach, I can tell whether the singers can improvise, are willing to move, and how generous they are with each other. I have always felt that auditions are very artificial and often painful events. By presenting the audition as a workshop situation, I'm able to give something back to the performers. Yuval was very open to this and then he started doing more group auditions.

*That's fascinating. It is such a different auditioning process in
the way you work. In terms of simply accepting another staging
or learning from another staging, what was the experience like
for you?*

It was pretty surprising. I saw the beauty of what Yuval did and
I also had some problems with certain aspects. But that is part
of the risk of doing a project like this.

What did you experience as problems?

Well, I felt that in some ways, the value system was somewhat
different. Not in terms of the deepest aspirations for the piece,
which I believe Yuval and I shared, but more in terms of the
production values and emphasis on scale, technology, and
effect. And again, this becomes very complex because here's
a question that you and I have also talked about a number of
times. For example, I asked myself, If I had done my produc-
tion now exactly as I did it before but had a different cast,
would it move people as much as Yuval's did, because the value
system of contemporary society is different from what mine
was? Or, as in *Quarry*, now looking at the restoration film of
the original production, which was made in my homemade
kind of style of the 1970s, in a sense, you could say it was anti-
techno, very tactile, and human-centered. Seeing the film of
Quarry now, it still seems to hold up. Recently, we showed it
at the Metrograph in New York City and it was the first time I
had seen it with the 5.1 sound surround system, meaning that
there are three speakers in front and two in the back of the

audience. We worked very subtly with making a 5.1 version for the soundtrack, and I think that it really brought the audience into the piece more.

I was very touched by all the young people who showed up for the screening. Afterwards, a few came up to me and said that they were really moved and had never seen anything like it. One young man said, "I've never seen anything as beautiful in my life." So then I was thinking maybe *ATLAS* as it was would be moving to people now, although the difference is that it was the original cast in the film of *Quarry*. With a different cast would it still hold up? Yuval's interpretation of *ATLAS* was awe-inspiring technically. What I was missing was some of the human scale. I wanted to be able to see the people more and feel their presence without being overwhelmed by the technology.

Is that a function of the use of media today?

I'm much more interested, even with a large piece, in a sense of intimacy.

You wanted it to be more emotional?

I wanted it to reach the audience in a tactile way. I felt like I couldn't see the performers well enough because of the huge orb that dominated the production and a film projected on it that was going on all the time. Yuval made a piece that is very techno-oriented, for people who have grown up with a smartphone in their hands. I have to say that even though our

sensibilities are different, the underlying spirit of *ATLAS* came through in his production. The young singers gave glowing, totally committed performances under his direction. I hope that they will get a chance to perform it again so that they can explore the material more deeply. The beauty of live performance is that you learn more and more about what you are doing as you go along. The material becomes part of your bones. It is an organic process.

I know this gets complicated, but we can never be living in the same kind of technological time as somebody who, from grammar school or high school, has used technology in a different way.

It becomes part of their nervous system.

For us, the attitude is probably more toward a critique of technology.

Yes, that's right. Exactly.

For them it's just a natural way of life. In any case, there is a difference between the time of the creation and the time of the restaging when you are dealing with an ephemeral art.

Exactly. And that's my question.

The issue is that a work lives through time, but the times are always going to be different.

Then what is the essence of the artwork? The essence of my philosophy is the integration and weaving together of many perceptual forms. That is what I have worked with all these years and what I am able to offer. Without that, what is the entity? Do you understand what I'm saying?

What we're talking about, what we are really asking, is, What is the contemporary? What does it mean to be contemporary? Your work, ATLAS, *was very contemporary in its time as* Quarry *was. And now, other audiences are looking at it as a contemporary work.*

Do you think that *ATLAS* was contemporary in its time, that it really ever had the feeling of the contemporary? I mean, even *Quarry* wasn't really contemporaneous with the styles of the era when it was made. I was working with an historical event, abstracting it and transforming it.

ATLAS *was a contemporary way of making an opera as opposed to a traditional way of making an opera. It had a female character at its center. It was ecological in orientation. It was about a spiritual quest. It had many elements that were important in the culture then. But the question is, with regard to the contemporary, Is it related to the time the work is made or does it refer to its ongoing relevance over time?*

This is something that I'm struggling with right now, the idea that if you reproduce the form, will it still have the same relevance? People who are born now are, in a sense, hard-wired

to their devices. People are accustomed to the technological as a means of communication. Yuval believes that you have to translate a work into the language of the time that we are living in. Basically, I know what he means and mostly agree with him, but I also think that there is a place to be able to experience work as it was conceived. One of the obstacles, of course, is that we are talking about live performance. That is very different from seeing an old film, reading a book, or looking at a painting from another century. I do think that music offers different possibilities. When I was working with the Young People's Chorus of New York City or with the French chorus, Mikrokosmos, my music still seemed to hold up. Audiences were very moved. So to me, the music didn't feel like it had a particular date. I have never felt that my work really had a particular date to it. What do you think? How do I talk about this with my own work?

Well, there is the example of Einstein on the Beach, *which has had at least three revivals in New York, all of them directed by Bob Wilson. I've seen all of them and the original. It was a different feeling with each different audience. For one thing, audiences now laugh at certain moments in the production whereas in the mid-1970s audiences would watch in silence. The sense of time is very different in each era it is performed. And it was done, let's say, as near exactly as possible. Lucinda Childs herself performed in three productions, the first two revivals and the original. On the other hand, I've also seen William Kentridge totally redesigning and reconceiving* Lulu, *or some of the classical operas. Restagings can work in many ways.*

I guess I am trying to clarify my thinking because I saw Kentridge's production of *Lulu* at the Met and I thought it was brilliant. His process of making a new incarnation of an older work is not the way opera is usually staged there. But what surprised me so much, working on the process of *ATLAS*, is that when I went back to the original videotape from the Brooklyn Academy of Music, I was struck by how intricate it was overall, that I was working with all the elements simultaneously, and how that seemed to inform the opera. I myself was stunned by it because I didn't remember that. Then I started questioning whether in the sense of my own integrity as an artist this is the right way for me to go or not because, again, the L.A. production was just an experiment for me. Maybe I have to think about it in terms more of …

Like a playwright. A playwright writes a play and then gives to a director to reimagine it.

Well, I never understood that, Bonnie. You know, I would say—up until the current production of *ATLAS*—that "I would never do that." That's why it remains such a complicated issue for me.

It's the history of drama. It's the history of production.

I know, but in my case the elements of the pieces are made so organically and are so connected to the performing of them that I never imagined separating them. Why would I ever want to do that? It's something I am thinking a lot about.

People move and speak in a different way today. Their faces are different, their gesture, their voices. You can never reproduce a work exactly. Even if you did it yourself it wouldn't be the same. That is just the natural life of an artwork that is constantly acted in other ways. I'm used to that concept in theatre because I come from the theatre.

The fact that performance is a living entity is what allows it to continually grow and change organically, so having younger people perform it is an opportunity to transmit a particular way of thinking about things. The challenge is how to teach those fundamental principles to new generations.

In terms of thinking about the ongoing life of your work, are you willing to have this process play itself out more? Are you willing to let go of your work if other people want to produce it?

Well, my Buddhist teacher, Pema Chodron, has written me letters that say, "Your job is to let go, let go, let go." I understand where the spiritual part of it is about letting go. But the art part of it—what is that exactly? Live performance has its own set of challenges. If you consider the L.A. production of *ATLAS*, is it actually *ATLAS*? Here we go into the artistic identity of a work. What makes it *ATLAS*? You know what I'm saying?

Here's another way to think about this. There is a certain paradox with regard to the contemporary or the visionary because in a way it starts out breaking traditions and subverting them and going against traditions. But then by showing new models, it starts on the road to developing new traditions.

Yes, that's interesting. That's really interesting.

They then become the standard by which newer work is judged. I have always loved Baudelaire's idea that modernity would eventually take its place with antiquity.

Yes, I understand what you're saying. It makes me think of when I was a member of A Bunch of Experimental Theatres in the seventies. I remember Richard Foreman saying something like that. He said, "I don't consider myself experimental, I'm a master now." I believe that Richard was referring to the theatre world that would categorize experimental as not being good enough for the mainstream, but I totally understand where he was coming from. While I certainly am far more sure of what I am doing after all these years, I still love to explore and never want to lose the sense of beginner's mind. Not knowing excites me. For each piece, I try to start with no assumptions or expectations.

Meredith, let me ask you something. As an older artist with a formidable body of work, do you feel like you have to constantly have new ideas or new forms?

I actually love the challenge of that. I've always loved to work with new forms. That is something that keeps me going from one day to the next.

Do you feel pressured at this stage?

I don't feel any pressure. It's to satisfy my curiosity that I continue to explore. I love to learn. Even if it might not be new for anybody else but is new for me, moments of discovery keep me going. I like the idea of maybe finding something that no one has tried before. I think I have always liked that. And showing that there are possibilities that maybe other people haven't thought of. It is more the sense that any pressure comes from just trying to figure out how to fulfill what I have discovered and not get in its way.

> *Are there issues and problems that you're still working out decades later? I mean, by now, there are certain things you have figured out, but are there questions that you haven't resolved or that you are still working through artistically? What are the things that preoccupy you now?*

My joy has always been working between the cracks of forms. I'll work on something and then after I've finished, I figure out what the form is in relation to categories, like *The Politics of Quiet*. I realized after I had worked on it and struggled with the fact that the piece didn't seem to want theatrical elements that much, it wanted to have more simple geometric kinds of configurations on stage. It didn't seem to want to have characters. Every time I tried for a kind of theatrical idea the piece would just reject it. Then I realized, Oh, this is a non-verbal oratorio form. When I was working on *Turtle Dreams*, after I did the waltz and I was working on it as a full-length piece, I discovered it was like a new cabaret form that somehow fell between a concert and a theatre piece. Then I thought, Okay, this is an apocalyptic cabaret.

What I am working on now with *Indra's Net* is an installation-performance form. What I mean by that is that I want to create a live-performance situation where the audience is reconfigured, and in some sections mobile, as well as a video installation that can run by itself without performers. It would probably be shown during the day between performances or in a museum at a later time. Since my early site-specific pieces in the late 1960s, I've been interested in varying and sometimes inverting the temporal and spatial relationship between audience and performers. I have been thinking about *Indra's Net* and its theme of interdependence and connection for the last ten years.

One of my inspirations was our performance of *Ascension Variations* at the Guggenheim Museum in 2009. During the second section, I invited the audience to walk up and down the ramps of the museum. Performers were spread out in the small alcoves throughout the rotunda, performing loops of musical and gestural material during a thirty-minute period. The music consisted of one section from *Songs of Ascension*, in which the singers and players were free to take elements from the piece and play them at any time during the duration of the section. There were also performers doing recurring gestural sequences. What evolved was a complex musical texture that filled the rotunda as well as the individual details that the audience could experience at close range. It was as if the whole building was singing and resonating. I want to develop this idea further in *Indra's Net*.

Since you are talking about Indra's Net, *I'd like to ask you about something that you have also spoken a lot about previously—space and time. I remember that I was intrigued when you said in an earlier conversation that you first got into films because you were more interested in reality and you wanted to experience the space of the world. What issues are you still dealing with in regard to space and time?*

I'm constantly working with and questioning these notions. How do I make an installation form in which the spatial idea informs the music? Last fall, members of my ensemble and I went to Mills College to try out a few pieces of material with some of the instrumentalists and singers there. In *Indra's Net*, I began with a spatial concept and tried to mold my material to it. Actually, I haven't worked that way in a long time. In recent years, I just start with the musical material itself and let the form develop organically from there. After the Mills sessions, I realized that the music had a life of its own that was somewhat different from my original concept. Now, I just have to follow where it is going and integrate the spatial concepts with that.

That is a challenging concept to grasp. How does space relate to music?

Well, first I should explain to you that *Indra's Net*—sometimes called Indra's Jewels or Indra's Pearls—is a traditional Hindu/ Buddhist legend reflecting universal spiritual principles. The principles that it symbolizes are interdependence and cause and effect, anything that an individual does affects everything

else in the universe. Everything is connected. The basic story is that Indra was an enlightened king—some think of him as a deity—who created a huge net covering the universe. At each intersection of the net, he placed an infinitely faceted jewel that reflected every other infinitely faceted jewel. This idea relates to chaos theory in our contemporary time.

It's another one of your patterns.

Pattern is involved of course, but how do you actually realize that structure musically? Working on it has been very rich and fascinating. I have been experimenting with different permutations of singer/movers and instrumental groups moving and regrouping during the piece so that the sonic experience would continually shift and morph.

It seems like an outgrowth of some of the recent pieces in which the musicians have been moving. Was it impermanence *where they were walking into the space? The musicians were lying on the floor in* Songs of Ascension *too. As you describe it,* Indra's Net *is a Buddhist as well as Hindu reference …*

I don't think it matters whether it is Buddhist, Hindu, Christian, this or that. It is just this idea that, especially ecologically, we all are dependent on each other. I consider *On Behalf of Nature, Cellular Songs,* and *Indra's Net* as a kind of trilogy dealing with nature and our relation to it, and to the ecology of community.

That's very important to know you think of those pieces in that way. Since the question of art as spiritual practice has been so essential to you are there new pathways that you've found in recent years in Buddhism now impacting your work? Has the effect of Buddhism on you changed over time?

Oh boy, that's really difficult. Thinking back, as a young artist I intuitively made work that reflected what I later learned were basic Buddhist principles: fluidity of time and space, stillness, silence, presence, immediacy. When I began doing formal meditation practice, I thought of it as separate from my art practice. Over the years, I began to sense that those two aspects were more integrated, certainly in terms of how I worked with other people. I don't think that I would have had the nerve in the early days to make a work called *impermanence* or *Indra's Net*. I was wary of the concepts and vocabulary being too specialized, not universal enough. But as time has gone by, I realize that my aspirations as an artist and human being line up with the Buddhist notions of ethical behavior. They are part of an overall desire to make work that is life-affirming, and that includes darkness as well as light, pain as well as joy.

I have always worked in that way intuitively but I now see more clearly that every aspect of my life imbues the work. There is no separation. That insight comes directly from my meditation practice. For the last twenty years or so, I have been devoting myself to working on projects in which contemplation becomes part of the artistic process. For example, making a piece called *impermanence* is an oxymoron, and yet working on it and thinking about the ephemerality of life, both our fragility and yet our resilience as human beings, was transformational.

In a larger sense, what brought you to Indra's Net?

As I said before, I've been thinking about this piece for ten years. When I was working on *WEAVE for Two Voices, Chamber Orchestra and Chorus*, commissioned by the St. Louis Symphony in 2010, I was going to call it *Indra's Net* because the music seemed to conjure vastness and dimensions of reality. But *WEAVE* as a title encapsulated the structure of the piece more accurately. When I began working on the music for *Indra's Net*, I started with very short but intricate instrumental pieces that shimmered and seemed to rotate. I called them "Jewels." Then I worked on other wider and more expansive sections involving both the instruments and voices that connected everything. I thought of them both as the net and as prayers for the future of the planet. I called one of them "Anthem."

As someone who went to Catholic school for twelve years, I can relate to the idea of prayer.

I call it an anthem but I think it's more like a prayer.

I think people do pray, in their own way. That's why I wanted to know whether your current practice of Buddhism was moving in new directions. You have talked in the past, for instance, about an audience being a congregation. It makes sense that you might think of prayer.

Absolutely. Something that I've talked about in our conversations is the idea of live performance offering an audience a direct and immersive experience that bypasses our habitual

patterns of thought. We have been trained to trust the part of our minds that filters out what is actually happening and translates it into a verbal interpretation that limits the possibilities of a full experience. We work on that a lot in meditation—being aware of thoughts, emotions, and sensations, then letting them go. I have been meditating for years but I'm telling you, it isn't easy to quiet down.

Something that continues to inspire me is the notion that what we are born with, our natural mind, is fundamentally good. Then, as we grow up and go on through life, it gets covered over with layers and layers of our learned experience, habitual patterns, and confusion. By meditating, we can peel back those layers of obscuration to get to what we were born with in the first place. The natural mind is radiant and translucent and it inherently "knows" that reality is constant change. Suzuki Roshi, the well-known Zen teacher who wrote *Zen Mind/Beginner's Mind* was asked by one of his students, "What is Buddhism"? And he answered, "Everything changes."

It is a coincidence you mention that because many people have been reading The Order of Time *by Carlo Rovelli. And that is what he says as well, that life is impermanence, a series of "events," not "things." That there is no real sense of time. We construct the past, the present, and the future, but those differentiations do not really exist. There is only now and there is only the present.*

We construct a fixed idea of who we think we are and project that misconception onto the world. We think that we are a particular entity, but in actuality all of us are changing every moment.

And to every other person who knows us. Given this world we
now live in, of constant turmoil and global crisis and unhappi-
ness, what do you feel the need to do now?

I feel the need to give people some level of inspiration that
creating, whatever that might mean to a person—I don't mean
necessarily only creating art but the act of creativity in life
and art—is still very important. That is the way we find our
agency in the world and understand that we actually do have
the capacity to make change. That's what I am hoping for my
work to do. And also, to affirm beauty, not in the simplistic
sense of the word, but to take the time to really see and hear
what is there, in silence and in stillness.

I recently saw Agnès Varda's last film, Agnès by Varda, *and also*
the Almodóvar film, Pain and Glory. *And I thought to myself,*
you know, I love these works. There is so little feeling of tender-
ness in the vast majority of art nowadays, or beauty, or emotion,
in whatever form.

Oh, I loved the film. I thought that Antonio Banderas was so
delicate, tender, and fearless. Almodóvar's vulnerability, relent-
less and uncompromising honesty, and the wisdom of someone
who has lived a life of integrity no matter the consequences,
was deeply moving to me. He was unafraid to expose the pain
in his life. I found the film incredibly touching.

I felt the same way about Agnès Varda's last work, where she is
sitting at a desk onstage in a big theatre and telling the audi-
ence about her films and her life, and then showing parts of

them. It was such a feeling of joy seeing this film. Your recent
Cellular Songs *went in that direction with the sublime con-*
figuration of the five female performers, in a deliberate turning
against the anger and patriarchy and violence in the culture.
In response, you made a piece about care and interdependence
that is actually demonstrated in the form of the piece, which is
also very beautiful.

That is exactly what I was aiming for. Before Trump was
elected, I had started working on the piece. Even then, I sensed
that the patriarchal impulse was coming back up again. Earlier,
we talked about cycles and the repetition of human behavior
manifesting at dark periods in history, referring to *Quarry.* As
I worked on what would become *Cellular Songs,* I sensed that
an all-female cast would be appropriate as a counterbalance to
what was happening in the world, but I was also interested in
the web of sound that I could make with voices in the same
sonic range. When you hear Katie Geissinger, Allison Sniffin,
and me singing the first three a cappella pieces, you actually
don't know who is singing what, even though our voices have
very different timbres, because the forms are so intricate and
woven. When I was working on those songs, I happened to
be reading Siddhartha Mukherjee's book, *The Emperor of All
Maladies,* and became fascinated with the phenomenon of a
cell: its intelligence, economy of means, and the cooperation of
all its components in order to function.

As I read the book, I sensed the synchronicity of the songs
I was working on with what I was learning about the nature of
cellular activity. The music seemed to reflect the rhythms and

energies of these processes. Then I began thinking about how the billions of cells in our bodies work together, and taking that idea further, thinking that if society could learn from cells, the basic unit of life, the earth would go on in a different way. I was thinking deeply about what we could offer as artists in direct response to what is happening in the world. I wanted to make a piece that offered an alternative prototype for human behavior affirming values of kindness, interdependence, generosity, and cooperation. I was working with the idea of the cell as the basic unit, physically and musically.

> *For me, it represents the idea of performance as a life science.* Cellular Songs *is a distillation to the most basic elements in a highly abbreviated form, but it's really about the world, the microcosmic and macrocosmic. It encompasses everything.*

That's been true, I think, starting with *mercy*—even with *Facing North*, you could say—that I have had this impulse to boil down what I am doing to its essence. That has been an impulse of mine for certainly at least the last decade, having the belief and the confidence and a kind of purity of perception to reveal essential principles of life.

> *What musical ideas were you exploring in* Cellular Songs. *Are you making new discoveries following this trajectory?*

Yes, musically, it was very new for me. Some of the pieces contained more dissonance and chromatic harmonies than I usually write, and the forms were almost like three-dimensional

sound sculptures. I was actually thinking very much about 360-degree visual modalities, which was also new for me because earlier my music had much more to do with layering. That process continued on in some of the sections. But in others you could hear the piece rotating as if it were a sculpture in space even though it was just a musical form.

That sounds intriguing because I was also thinking of a kind of music of the spheres.

Yes, and then these intricate, very tiny articulations. It seems like the articulations are very small, and yet, when you hear the overall piece it is very complex.

Is it more difficult for the singers?

It's very challenging. What I really like about working with the four women in the piece is that, when you hear the musical forms, you know that to be able to perform them took a lot of work, and that the working is part of the form. I love that the work itself, cooperative work, is literally implicit in the musical forms because there's no way that anybody could perform these pieces without hours and hours of intensive labor. I love that you hear that in the work. It has, for me, a very poignant feeling.

And for the audience, it is a witnessing, while on the part of the performers who are creating it, a modeling of human behavior. Theatre is always potential for the future.

There is something about when you are in the moment, and you know that you are really present, that allows something to go through you, so there is a kind of radiance or luminosity. The other thing that is very beautiful is vulnerability. Vulnerability is one of the most valuable qualities that we have to share with other human beings.

Is there a name for this form?

Music, image, gesture theatre—I don't know, really. It is not a concert because there is movement. It is not theatre in that it doesn't have characters, particularly. It is very essential, each performer is actually herself. We are individual human beings.

I began to think of Cellular Songs *as kind of a singing meditation.*

It definitely has a ritual quality to it. Don't you feel that way?

Yes, there are ritualistic elements, for example, the laying on of the hands. What I think about your work is that when you really begin to pay attention to it and understand the ethical underpinning, it is evident that the work manages—structurally, musically, and thematically—to embody a philosophical point of view. That's very hard to do.

I'm so grateful that you would say that because that certainly is what I am trying for.

*In effect, what you are describing as the alternate social model
that led you to make* Cellular Songs *is essentially what being
"contemporary" means. It is being able to see things ahead of
time or of your time and to understand what may not be mani-
fest yet, but what's coming, and what the Zeitgeist is.*

The form does not necessarily have to be new nor does it have
to be fashionable. That's a complex issue because I feel like there
is a difference between reacting and responding. I had made a
conscious decision to make *Cellular Songs*, and I allowed myself
to make a piece that was abstract at a time when I was think-
ing, Is this relevant? Should I be doing more politically explicit
work? But if you look at the piece, you do sense that this artist
was not making it abstract as a kind of escape that has nothing
to do with what is going on. It's abstract, but there is still the
underlying response to what is going on without making an
explicitly political form. It's not uninformed in terms of the
world. I hope that many years from now it will still hold up
because it is not dependent on what is happening right now.
Do you know what I am saying about the differentiation?

*Yes. And regarding the idea of the contemporary, it is only in
recent decades that people have begun to think of it as perhaps
representing only five years or ten years. Remember when people
used to talk about the modern world that would extend for
decades? The idea of "modern drama" would refer to a half-cen-
tury or more. The contemporary has contracted so much that we
mistakenly just think of it as right now. But it can last a long
time just the way modernity lasted for so long. Our definitions*

are too paltry. We see this all the time with novels or operas or pieces of music and plays being rediscovered. The time of the work is always open-ended, in a sense.

Yes. That's the way I like to think about it. If there is a sense of honesty in it, and if the piece has its own integrity, I think that you could look at it at any time and it would still have something to say to anyone. It will retain its essence.

That's really the underlying point, that it is the integrity of form that really matters. Roland Barthes also wrote about the morality of form. I think that we need to be mindful of that.

That's so powerful and beautiful.

Often, the subject of form is dismissed in favor of more political rhetoric, but we are missing all these other nuances and dynamics about form, the beauty of form, the morality of it, the integrity of form. We need to think about resistance and the contemporary in a more expansive way.

Exactly. I feel like working this way is my resistance. I always say to young people that even making a piece, it doesn't matter what it is, is political. Making artwork is a political act. It's intrinsic. I believe that very strongly.

And now, looking to the work ahead, what are your thoughts?

For the last few years, the mystery of how a work comes to life seems to me more magical than ever. I can trace my work, the hours I put in, the decisions I made, even when certain shards of material came up. How it seems to coalesce at a certain point in the process and becomes itself still fills me with awe. There is a kind of logic or inevitability about the form. As I work on *Indra's Net*, the music and ideas keep pouring out as if from a larger intelligence. The act of creating, starting from curiosity, seems to keep my life force flowing and gives me a feeling of vitality. My friend, Paul Holdengräber, who is a great thinker, told me about something that John Cage said to the painter Philip Guston: "When you start working, everybody is in your studio—the past, your friends, enemies, the artworks, and above all, you, your own ideas—all are there. But as you continue painting, they start leaving, one by one, and you are left completely alone. Then, if you are lucky, even you leave."

I really sense that these days and it gives me great comfort. I feel part of a larger whole.

(JANUARY 6, 2020)

LIST OF IMAGES

Pg vi: Meredith Monk singing "Gotham Lullaby." *Music Concert with Film,* City Center, New York, NY, 1981. Photo: Johan Elbers.

Pg xv: *impermanence.* Left to right: Katie Geissinger, Meredith Monk, Ellen Fisher, Ching Gonzalez, Theo Bleckmann. BAM Harvey Theater, Brooklyn, NY, 2006. Photo: Stephanie Berger.

Pg xvi: Meredith Monk filming *Ellis Island.* Left to right: John Bollinger, Bob Rosen, Jerry Pantzer, John Sennhauser, Meredith Monk; Right foreground: Lee Nagrin, Jolie Kelter. Ellis Island, New York, NY, 1981. Photo: unknown.

Pg 2: Film still from *16 Millimeter Earrings,* directed by Meredith Monk, 1966. Cinematography: Kenneth Van Sickle. Courtesy Meredith Monk.

Pg 63: Meredith Monk, 2014. Photo: Julieta Cervantes.

Pg 64 (top): Meredith Monk in *ATLAS: an opera in three parts.* Houston Grand Opera, Houston, TX, 1991. Photo: Jim Caldwell.

Pg 64 (bottom): "Airport" from *ATLAS: an opera in three parts.* Left to right: Allison Easter, Ching Gonzalez, Chen Shi-Zheng, Robert Een, Meredith Monk. Théâtre de l'Odéon, Paris, France, 1991. Photo: Larry Watson.

Pg 65: Yoshio Yabara costume rendering and storyboard for *ATLAS: an opera in three parts,* 1991. Courtesy Yoshio Yabara.

Pg 66 (top): *Magic Frequencies.* Left to right: Katie Geissinger, Meredith Monk, Lanny Harrison, Ching Gonzalez, Theo Bleckmann. Power Center, Ann Arbor, MI, 1998. From the archives of University Musical Society, Ann Arbor, MI. Photo: David Smith.

Pg 66 (bottom): *Songs of Ascension.* Ann Hamilton, *tower,* Steve Oliver Ranch, Geyserville, California, 2008. Photo: Babeth M. VanLoo.

Pg 67: Meredith Monk score for "Falling" from *Songs of Ascension,* 2008. Courtesy Meredith Monk.

Pg 68 (top): *On Behalf of Nature.* Back to front: Bohdan Hilash, John Hollenbeck, Sidney Chen, Meredith Monk, Allison Sniffin, Katie Geissinger, Bruce Rameker, Ellen Fisher. Clarice Smith Performing Arts Center, University of Maryland, College Park, MD, 2013. Photo: Julieta Cervantes.

Pg 68 (bottom): *Cellular Songs* (showing of work-in-progress). Clockwise from front: Meredith Monk, Katie Geissinger, Ellen Fisher, Allison Sniffin, Jo Stewart. Queenslab, Ridgewood, NY, 2017. Photo: Julieta Cervantes.

Pg 69: Meredith Monk ground plan for "Nyems" from *Cellular Songs*, 2018. Courtesy Meredith Monk.

Pg 70: Meredith Monk receiving the National Medal of Arts from President Barack Obama. The White House, Washington, DC, 2015. Photo: Leigh Vogel.

Pg 92 (top): *Education of the Girlchild: an opera*. Front row, left to right: Sybilla Hayn, Coco Pekelis, Lee Nagrin; Back row, left to right: Blondell Cummings, Lanny Harrison, Monica Moseley, Meredith Monk. Common Ground, New York, NY, 1973. Photo: Lois Greenfield.

Pg 92 (bottom): *Book of Days*. Left to right: Toby Newman, Pablo Vela. Jewish Cemetery, Worms, Germany, 1988. Photo: Dominique Lasseur.

Pg 134: "Rally" from *Quarry: An Opera in Three Movements*. On floor: Meredith Monk; Front to back: holding hats and planes, includes Gaynor Coté, Ann Gentry, Amy Schwartzman, Andrea Levine, John Bernd, John Miglietta, Margo Corrigan, Jim Kelly. La MaMa Annex, New York, NY, 1976. Photo: Johan Elbers.

MEREDITH MONK is a composer, performer, director, chore-ographer, and filmmaker, internationally celebrated for her new vocabularies of contemporary performance. In 1968 she founded The House, a company dedicated to exploring inter-disciplinary arts. The following decade she formed Meredith Monk & Vocal Ensemble, featured on numerous recordings and in worldwide performances. In addition to her vocal pieces, music-theatre works and operas, Monk has composed for orchestra, chamber ensembles, and solo instruments, with commissions from Michael Tilson Thomas/San Francisco Sym-phony and New World Symphony, Kronos Quartet, St. Louis Symphony, Los Angeles Master Chorale, and Carnegie Hall, where she held the 2014-15 Richard and Barbara Debs Com-poser's Chair in conjunction with her fiftieth year of working in the arts. She performed a Vocal Offering for the Dalai Lama at the World Festival of Sacred Music in Los Angeles in 1999. Her music can be heard in films by Terrence Malick, Jean-Luc Godard, David Byrne, and the Coen Brothers. Monk has made more than a dozen recordings, most of them on the ECM New Series label, including the Grammy-nominated *impermanence*. Selected scores of her work are available through Boosey & Hawkes.

Monk is the recipient of the MacArthur Fellowship, sev-eral Obies and Bessies, and Officer of the Order of Arts and Letters from the Republic of France. Among her many operas and music-theatre works are *16 Millimeter Earrings*, *ATLAS*, *Education of the Girlchild*, *mercy* and *Songs of Ascension* (both

in collaboration with Ann Hamilton), *The Politics of Quiet*, *Quarry*, and *Vessel*, a pioneering site-specific piece. Her music-theatre works *On Behalf of Nature*, *Cellular Songs*, and the forthcoming *Indra's Net* form a trilogy on the interdependence of human beings and nature. Monk's filmography includes *Book of Days*, *Ellis Island*, and a collection of short silent films. Her visual art works and installations have been exhibited at the Walker Art Center, the New York Public Library for the Performing Arts at Lincoln Center, the Whitney Biennial, and the Frederieke Taylor Gallery in New York City.

In recent years, Meredith Monk has received three of the highest honors bestowed on an American living artist: induction into the American Academy of Arts and Letters, the Dorothy and Lillian Gish Prize, and the National Medal of Arts from President Barack Obama.

BONNIE MARRANCA is founding publisher and editor of the Obie-Award winning PAJ Publications and *PAJ: A Journal of Performance and Art* (1976-). A recipient of the Association for Theatre in Higher Education Excellence in Editing Award for Sustained Achievement, she is the author of *Performance Histories*, *Ecologies of Theatre*, and *Theatrewritings*, which received the George Jean Nathan Award for Dramatic Criticism. Her edited volumes of plays, essays and interviews include *New Europe: plays from the continent*, *Plays for the End of the Century*, *Conversations on Art and Performance*, and *Interculturalism and Performance*. A Guggenheim Fellow, she has also received the Leverhulme Trust Visiting Professorship (UK), Asian Cultural Council Fellowship (Japan), Fulbright Senior Scholar Fellowship (Free University, Berlin), Anschutz Distinguished Fellowship in American Studies (Princeton University), and recently, the Emily Harvey Foundation residency (Venice) and Bogliasco Foundation Fellowship (Liguria). Bonnie Marranca has taught and lectured widely in American universities and abroad. She is Professor Emerita of Theatre at The New School/ Eugene Lang College of Liberal Arts.